Watercolor WITH Me

IN THE FOREST

Watercolor with Me

IN THE FOREST

DANA FOX

PAGE STREET
PUBLISHING CO.

First published in 2018 by
Page Street Publishing Co.
27 Congress Street, Suite 105
Salem, MA 01970
www.pagestreetpublishing.com

Distributed by Macmillan, sales in Canada by The Canadian Manda Group.

24 23 22 21 20 7 8 9 10

ISBN-13: 978-1-62414-556-8
ISBN-10: 1-62414-556-6

Library of Congress Control Number: 2017956919

Cover and book design by Dana Fox

Printed and bound in Italy

To everyone with a creative, colorful spirit
and a sense of childlike imagination.

INTRODUCTION

Watercolor with Me in the Forest is a watercolor project book that allows you to create beautiful artwork and learn a little something as you do it. It was designed to let your creativity shine through while making the idea of watercolor painting a little less terrifying for beginners.

This book will guide you step-by-step through creating each of the paintings shown. On the left, you'll see a faint sketch of the image. On the right, you will find the tips, instructions, color palettes, and tools required to complete the artwork.

The projects are broken up into four main sections:

- Wet on Dry
- Wet on Wet
- Painting Fur
- Ink and Wash

You'll be able to learn about these techniques before you start painting so you can confidently put that brush to paper.

Supplies you'll likely need:
- Round watercolor brushes (sizes 2 to 6)
- Fine detail brush
- Watercolor paint
- Clean water
- Mixing palette
- Permanent ink pen
- White gel pen
- Paper towels

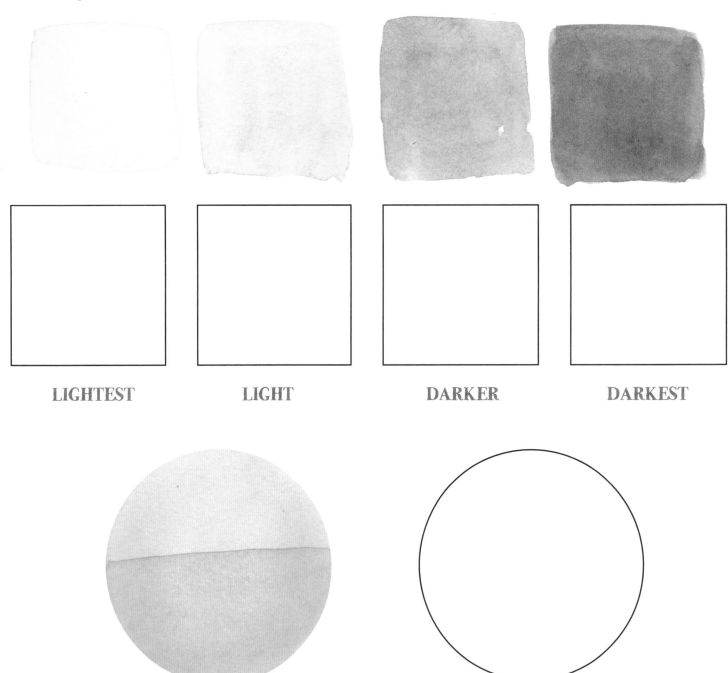

LIGHTEST **LIGHT** **DARKER** **DARKEST**

WET ON DRY

The first paintings in this book are done using a wet-on-dry technique. This simply means that the paper is not wet prior to touching your brush to it.

Wet on dry allows you to have more control over where your paint goes, and it allows you to add detail and achieve sharp, crisp lines.

When painting on a dry surface, you want to make sure that your brush is holding enough water so the paint mixture can flow freely. Without enough water in your mix, you'll end up with a dry brush effect.

With all watercolor techniques, the amount of water versus pigment (paint) will determine how light or dark the color appears on your paper. The more water, the more translucent the paint will be—thus making it lighter in color. The less water, the more opaque or vibrant the color will appear.

Wet on dry is also a technique used when you want to build up layers, adding paint to dry layers of previously painted areas. You can create textures and finer details this way because you have control over the placement and don't have to worry about the paint flowing into other areas.

On the opposite page, fill in each square with a mix of your paint and water. Start with a very diluted mixture (more water with less pigment), and gradually increase the amount of pigment (less water) in each box.

Then, fill in the circle with a single light color. Let it dry completely. Now, apply a second layer onto the bottom half to see how building layers can increase the intensity or darkness of the painting.

Acorns

Acorns have a lot of texture to them. Using shadows, highlights and lines to mimic that look is what you'll try to do here.

By using different shades of brown, you'll create layers of wet-on-dry washes to really build up those darker areas. The bottom half of the acorns should appear "streaky" like the texture of a real acorn.

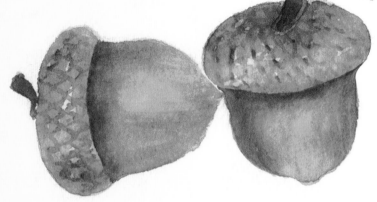

Colors

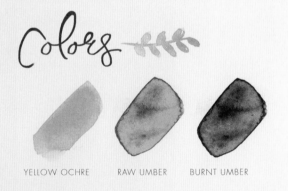

YELLOW OCHRE RAW UMBER BURNT UMBER

Supplies

- Round brush (size 6 works well)
- 3 colors of paint

1. Working on the bottom half of the acorns first, fill the areas with a light wash of Raw Umber mixed with Yellow Ochre.

2. After a few minutes, once dry, add a second wash of the same color. Try to mimic the streaky texture of an acorn by painting light lines from the top of the area to the bottom point.

3. Add another layer using Burnt Umber around the bottom, top and sides of the acorn. You can blend any harsh edges out with water.

4. Fill the acorn tops with a light wash of Burnt Umber, and then apply additional layers as you did previously, darkening shadowed areas such as the center and sides of the tops.

5. Let the previous layer dry once again, and create a scale-like pattern in the top of the acorns with a thin brush tip and Burnt Umber. Try to keep the paint lighter in areas where the paint is lighter, and darker where the shadows have formed.

6. Fill in the acorn stems with Burnt Umber and you're done!

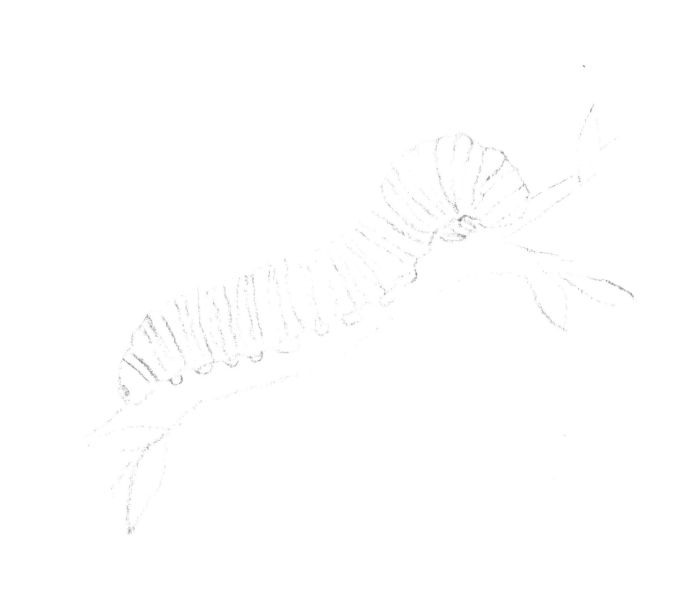

Caterpillar

Caterpillars come in a variety of colors, so feel free to use whatever hues speak to you for this exercise!

The black details can be done with ink instead of paint, if you prefer. White accents can be added with a white pen or a more opaque paint such as acrylic or gouache.

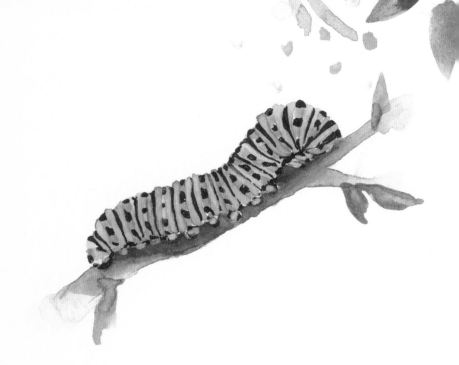

Colors

| SAP GREEN | RAW UMBER | IVORY BLACK | YELLOW OCHRE |

Supplies

- Fine brush (size 2 or 3 works well)
- 4 colors of paint
- Black ink pen (optional)
- White gel pen (optional)

1. Start by filling in every other stripe with your main color, in this case Sap Green.

2. Once dry, paint the tree branch using Raw Umber, and add a darker shade of Raw Umber mixed with Ivory Black under the caterpillar for a shadow.

3. Using Yellow Ochre, add dabs of the color to each blank stripe along the body.

4. Once the yellow is dry, go in with a black ink pen or Ivory Black paint and fill the remaining areas beside the yellow spots to create the spotted stripes.

5. You can now add leaves to your tree branch. Finish the feet with black, adding white highlights afterwards.

Fern

Fern leaves are a great accent piece to add to any painting, and they are so easy to create! The leaf shapes require a steady hand with light pressure and a pointed tip, especially when working on a small-scale piece. They only require one color, but you can add interest by mixing another shade with your main color to obtain a true watercolor effect.

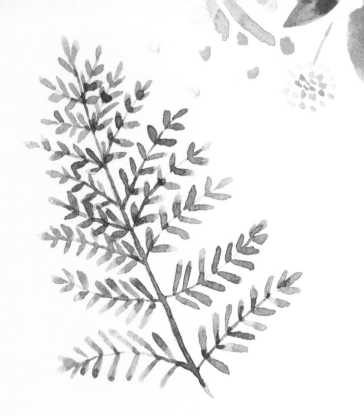

Colors

HOOKER'S DARK GREEN BURNT UMBER

Supplies

- Fine tipped round brush (size 6 pointed)
- 2 colors of paint

1. Start by painting the middle stem using a fine tipped brush and a mix of Hooker's Dark Green and Burnt Umber. The consistency shouldn't be too watery as it will be harder to get a thin line with more water.

2. Paint the stems of the leaves branching off from the main stem while it is still wet. This will allow those stems to blend into the main one seamlessly.

3. Starting at the top of the main stem, paint a small upside-down teardrop shape with the same green shade, followed by two on either side.

4. Add teardrop shapes to each leaf stem. For interest, you can dot on a darker shade of your mix to some of the leaves while they are wet.

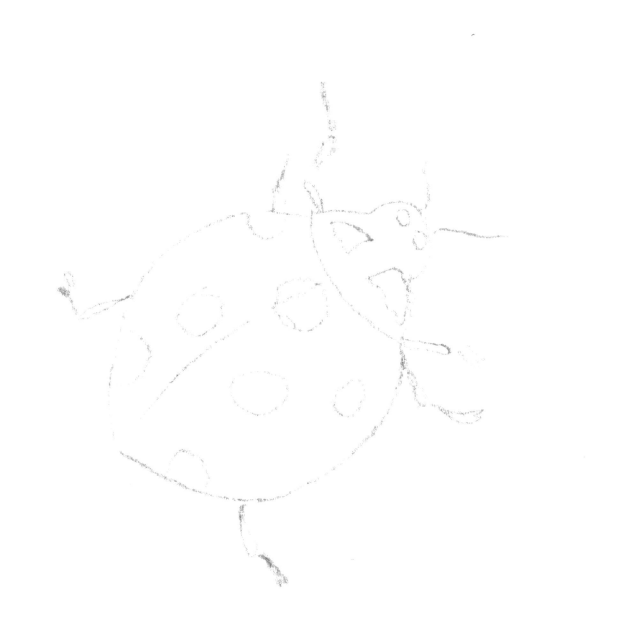

Ladybug

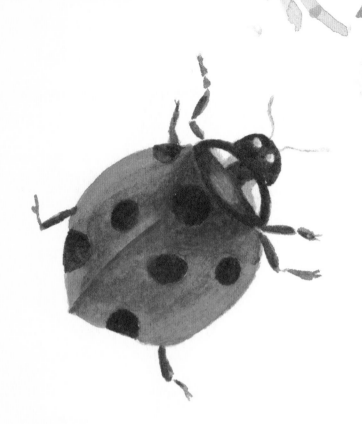

This ladybug is created using two shades of red and a little bit of white pencil for highlight details. The center of the back appears darker and gets lighter as the color moves out toward the edges. You can use black paint or a black pen for the black details.

Colors

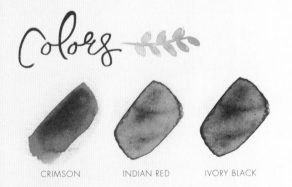

CRIMSON INDIAN RED IVORY BLACK

Supplies

- Round brush (size 6 works well)
- 3 colors of paint
- White pencil
- Black ink pen, optional

1. Start by filling the body of the ladybug with Crimson red. Make this a light wash as it will just be the base for the following layers.

2. Let the base layer dry for a few minutes. Apply a second layer, this time adding a more pigmented Indian Red to the top center of the back. Using less water will result in higher pigmentation.

3. Let the paint dry once again. Then, fill in the black portions such as the head and legs with either Ivory Black paint or an ink pen. Make sure to leave the white details on the head untouched.

4. Add spots to the back, and finish by adding a few white highlights to the red as pictured.

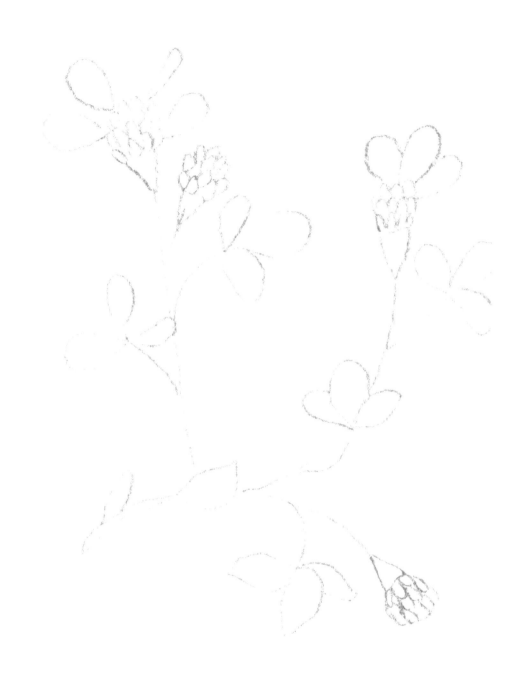

Clovers

The green tones in these clovers are all created using the same color, by adding more or less water to increase or decrease the intensity. The more water you add, the lighter the green will appear, whereas the less water you add, the more pigmented it will be. Use a fine brush or a round brush with a thin pointed tip for the veins.

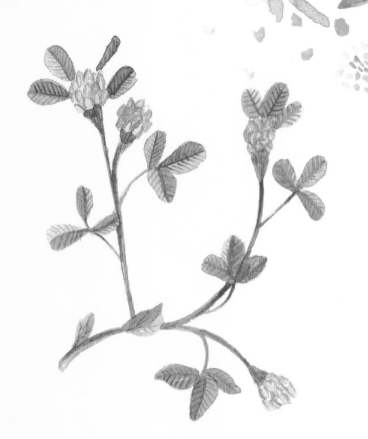

Colors

HOOKER'S DARK GREEN YELLOW OCHRE RAW UMBER

Supplies

- Round pointed brushes (sizes 1 and 5)
- 3 colors of paint

1. Using a light wash of Hooker's Dark Green mixed with a touch of Yellow Ochre to make it more of a yellow-green shade, fill in the leaves completely.

2. Continue to the stems, using a light hand and thin brush tip.

3. After a few minutes of letting the paint dry, add another slightly darker wash of the green mixture to one half of the leaves, and down the stem for a shadow-like appearance.

4. Mix a little bit of Raw Umber with Yellow Ochre and water to get a beige tone. Fill in the buds.

5. Once those layers are dry, add lines to the leaves with a darker green tone, and outline the buds with a darker tone of your beige mixture.

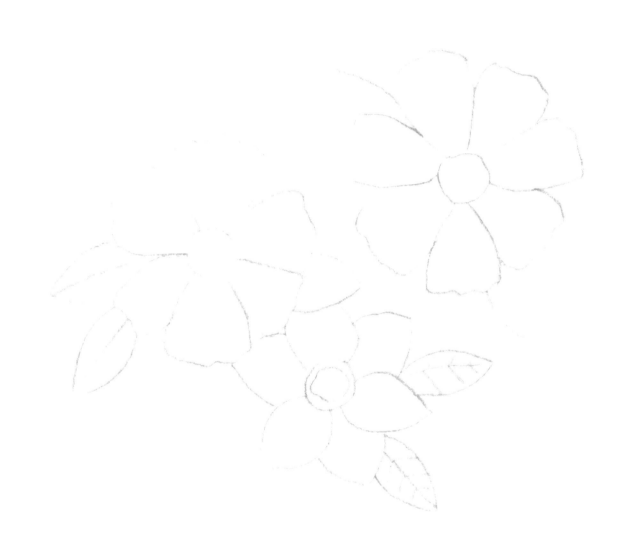

flowers

There are many different types of flowers and many techniques to paint them, but perhaps the easiest method is wet on dry. This allows you to control your paint and where you place it, and it also makes adding outlines easy.

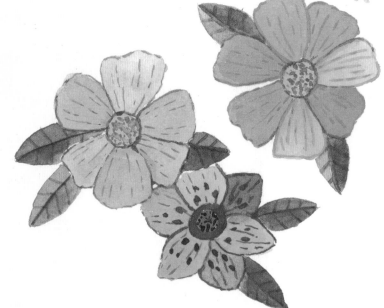

Colors

| YELLOW OCHRE | ROSE | INDIAN RED | HOOKER'S DARK GREEN |

Supplies

- Round pointed brush (size 6 works well)
- 4 colors of paint

1. Start by painting the petals individually using mixtures of Yellow Ochre, Rose and Indian Red. A little Yellow Ochre added to Indian Red will produce an orange shade. Rose mixed with Indian Red will tone down the pink hue a little as well. Experiment with different mixtures of color to find ones you love!

2. After a few minutes, once dry, paint the center areas of each flower using Yellow Ochre. Fill in the leaves with a mix of Hooker's Dark Green and Yellow Ochre.

3. With a shade darker than your petals, paint outlines around each petal. Add broken lines to the inside of each one. Add dots to the centers of the flowers as well.

4. Using a darker shade of the leaf color, add the line detailing to the leaves.

5. Finish by adding more dots or details to the petals as you see fit!

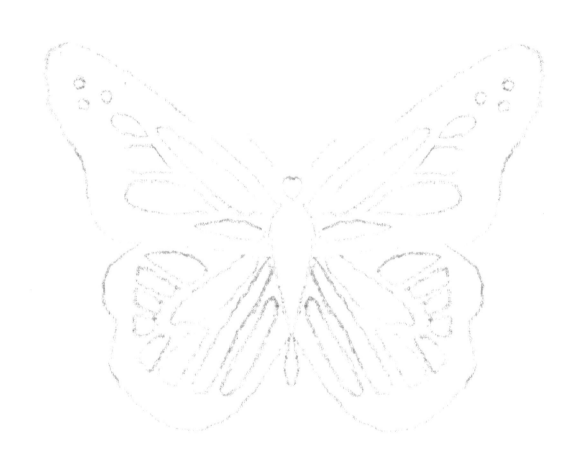

monarch

A Monarch butterfly has a lot of little details that are a lot of fun to color in. When using the black, you may need to go over your first layer to make it darker since the paint will dry lighter.

By filling in each orange section separately, you can create unique washes for each area as opposed to filling in the entire wing as a whole.

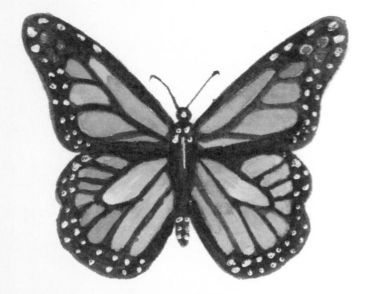

Colors

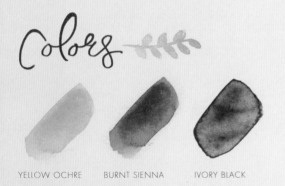

YELLOW OCHRE BURNT SIENNA IVORY BLACK

Supplies

- Round brush (size 3 works well) or fine brush
- 3 colors of paint
- White gel pen or white gouache

1. Mix together a little Yellow Ochre with Burnt Sienna and water for a yellow-based orange.

2. Fill each wing section with the mixed color, making sure not to touch the sections together with the paint. To do this, leave small spaces of exposed paper in between each orange section.

3. When the paint is dry after a few minutes, paint the black outlines and body with Ivory Black using the tip of your brush or a fine brush, covering any exposed paper spaces that were left.

4. Once the piece is completely dry, add the white dots with a white gel pen or white gouache.

tree

You can layer different areas using a stippling technique by creating dot-like strokes with your brush. This increases the intensity or darkness of a color. This allows the leaves of the tree to appear to have shadows and highlights, all while using the same color throughout.

Using just two colors for the leaves and the trunk, you can quickly create this simple tree.

Colors

BURNT UMBER HOOKER'S DARK GREEN

Supplies

- Round brush (size 6 works well)
- 2 colors of paint

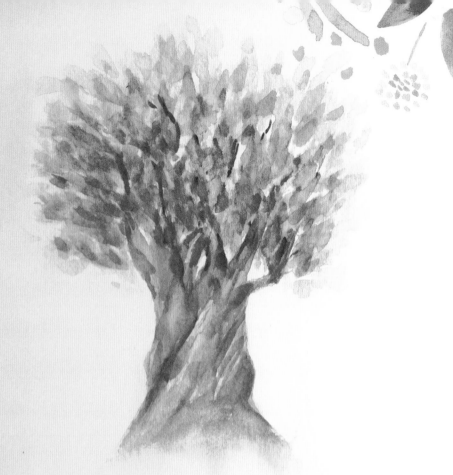

1. Begin by painting on a light wash of Burnt Umber to the trunk. As the base layer dries, go back in with a more pigmented mix of Burnt Umber and add the line details and dark areas to the trunk.

2. Move on to the top of the tree and begin stippling in some leaves using a lighter wash of Hooker's Dark Green paint diluted with water.

3. Once the layer is dry, add another layer of stippled leaves using a slightly more pigmented mix of paint (less water). Continue stippling and darkening your mix until you are happy with how it looks and until the white space is nearly filled.

4. After your leaves are fully dry, add indications of the branches peeking through the leaves with Burnt Umber. Add shadow detailing to the trunk with the same color.

moth

This moth has a lot of fine details, but is created using just a few colors and a fine tipped brush.

The wings are created using a very watery mix of color with darker shades dropped in for texture. The fine lines are added once the first layer has dried.

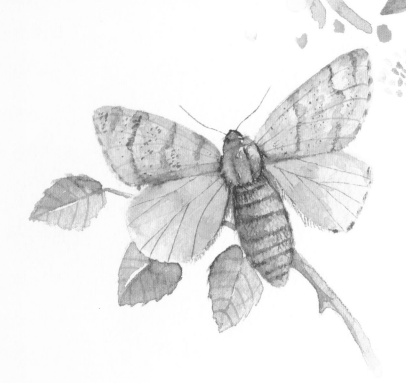

Colors

RAW UMBER BURNT UMBER HOOKER'S DARK GREEN

Supplies

- Round brush (size 6 works well)
- 3 colors of paint
- Fine detail brush

1. Start by filling the wings with a light wash of Raw Umber, dropping in darker shades (less water) of the same color to the wet areas for texture.

2. Do the same with the body using a light wash of Burnt Umber. Let both areas dry completely for a few minutes.

3. Using a darker mix of Burnt Umber and the tip of your brush, wiggle a few vertical lines down the top wings.

4. With a fine detail brush and Burnt Umber, create small, short strokes on the body to create the horizontal lines and furry texture.

5. With the same brush and Burnt Umber, lightly draw fine veiny lines down the wings and add the antenna.

6. For the leaves and twig, mix Hooker's Dark Green with Burnt Umber and fill in the areas. Let dry completely. Finish off the veins in the leaves with Burnt Umber and the fine detail brush.

Dogwood Rose

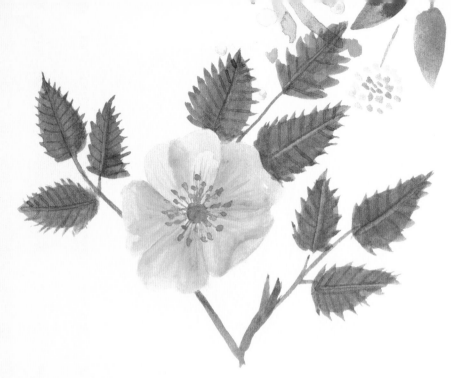

Wildflowers help add a bit of a dainty touch to the woods with their pastel shades and soft petals.

This dogwood rose looks super feminine amongst the pointy leaves, and it is a pretty quick piece to complete.

Colors

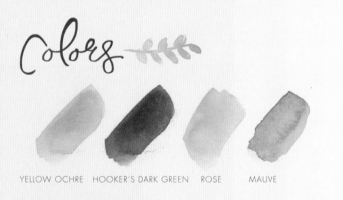

YELLOW OCHRE HOOKER'S DARK GREEN ROSE MAUVE

Supplies

- Round brush (size 6 works well)
- 4 colors of paint
- Fine detail brush

1. Starting with the leaves, mix a little bit of Yellow Ochre with Hooker's Dark Green to tone down the green. Fill your first leaf with the shade and, while the paint is still wet, drag out little pointed strokes using a detail brush around the edges.

2. Paint all of the leaves this way. Then add the stems using the detail brush once again.

3. After waiting a few minutes for the leaves to dry, use a slightly more pigmented (less water) mix of the same green and add the vein lines to the leaves.

4. For the flower, mix up a touch of Rose with Mauve and a good amount of water to create a diluted, pastel shade. Fill one petal at a time with the color, allowing each one to dry before moving onto the next.

5. To add darker details and shadows to the petals, apply a darker (less water) mix of the same shade around the petal edges. Dry off your brush and run it along the wet edges to blend out the color.

6. Let the whole painting dry. Then add the center dot details using Yellow Ochre.

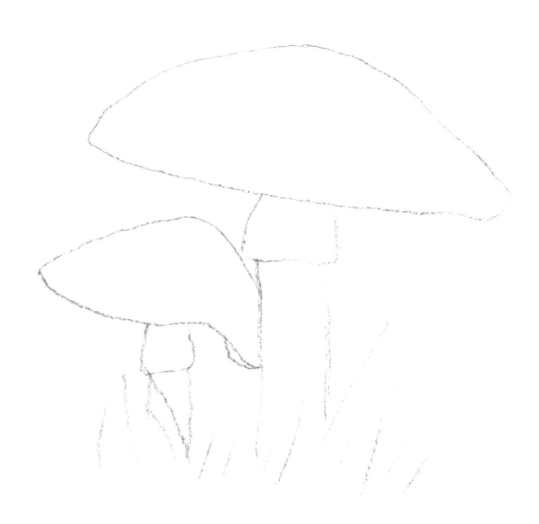

mushrooms

Mushrooms come in so many varieties, colors and shapes. These red ones stand out in nature, making them tempting to incorporate into your decor.

Instead of picking them, why not try painting some to hang on your wall?!

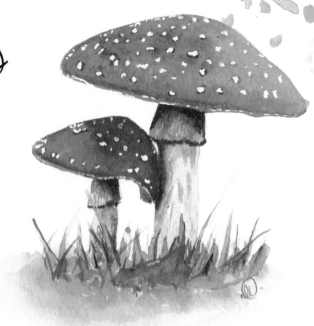

Colors

INDIAN RED BURNT UMBER RAW UMBER HOOKER'S DARK GREEN

Supplies

- Round brush (size 6 works well)
- 4 colors of paint
- White gel pen
- Fine detail brush

1. Starting with the tops of the mushrooms, fill the entire area with Indian Red. Let dry for a few minutes.

2. Add a touch of Burnt Umber to your Indian Red mixture. Now, add some shadow areas to the middle, edges and top of the small mushroom.

3. For the stems, mix a tiny amount of Raw Umber with water for an off-white shade and paint them. After letting the stems dry, darken the Raw Umber mixture with more paint and apply light streaks to the base.

4. The top stem can be darkened using a more concentrated mix of Raw Umber and Burnt Umber. Using Burnt Umber for your shadow areas, create darkness under the mushroom tops and along the edges of the top of the stem.

5. When the mushrooms are dry, paint in the grass with Hooker's Dark Green mixed with Burnt Umber and use a fine detail brush for long, thin blades of grass.

6. Using a white gel pen, add the white spots to the tops.

Cabin

Paint your own rustic getaway! This cabin in the woods is the perfect place to let your mind wander.

The trees behind the cabin are simplified and freehanded, bringing attention to the cabin itself. A few colors are all you need to start painting it.

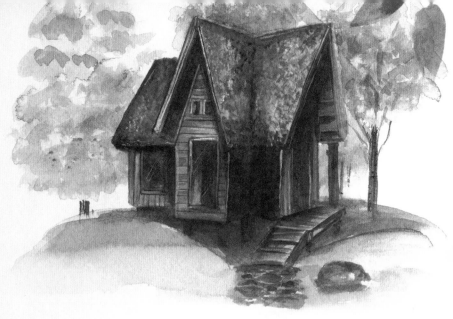

Colors

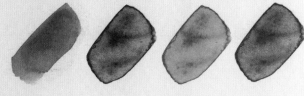

HOOKER'S DARK GREEN BURNT UMBER RAW UMBER PAYNE'S GREY

Supplies

- Round brush (size 6 works well)
- 4 colors of paint + white paint
- Fine detail brush

1. Start by creating loose trees in the background by using your brush to stipple various shades of Hooker's Dark Green mixed with the brown shades. Add the tree trunks.

2. For the roof, mix a ratio of 1:1 water and Burnt Umber and apply it to the whole area. Let dry for a few minutes.

3. With a more pigmented shade of Burnt Umber (less water) shade the center line where the middle and right-side roof connect, as well as the left-side roof.

4. Paint the cabin walls and deck with Raw Umber. Let dry.

5. Fill the darker areas with Payne's Grey, such as the underside of the roof, the windows, and the corner where the two walls meet.

6. The roof should be dry now, so stipple on some green for a mossy effect, followed by Burnt Umber for dimension.

7. With the walls dry, use a thin detail brush to paint the wood panel lines across the exterior. Add white highlights to the windows and some of the edges of the cabin with white paint.

8. Paint the ground green and finish the pathway rock details with alternating brown and grey shades.

try it →

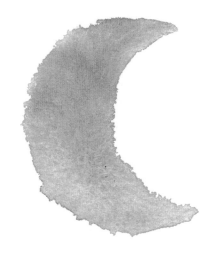

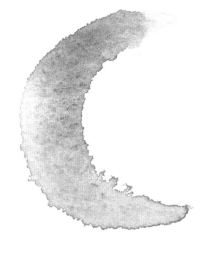

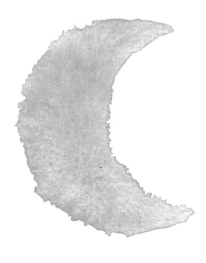

WET THE PAPER

DROP IN COLORS

TILT TO BLEND

WET ON WET

Wet on wet is the process of adding paint to an already wet surface. You can do this in two ways:

- Coat your paper with water and apply paint to it
- Apply more paint to an area that contains wet paint

With this method, the results you'll experience are less crisp than the wet-on-dry method, and you'll find the application isn't as controlled.

With wet on wet, you're giving up control, and you're letting the paint and water do what they like.

To practice this technique before diving into the next projects, take a look at the page beside this one.

Using a brush, wet the moon shape entirely with clean water so the paper is shiny. While the paper is still wet, get some paint on your brush and touch it to the wet area.

Try again with another color; dabbing it on and watching it expand. You can coax it along the wet area with your brush too!

Now, tilt the paper and let the colors blend together. You'll see that the paint only flows to where the paper had been wet and not outside of those boundaries.

If you've got the hang of it, jump right into the next projects!

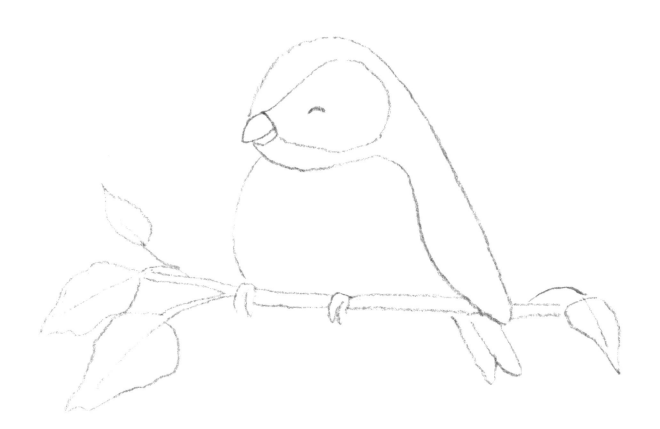

chickadee

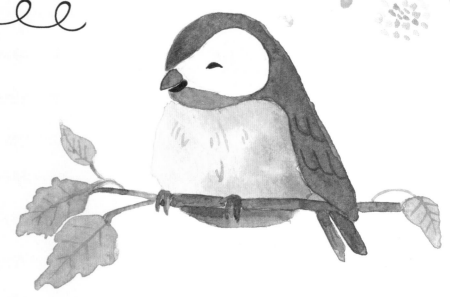

With the wet-on-wet basics you practiced on the previous page, create this happy Chickadee sitting on a branch.

In this painting, you're going to control the placement of colors and let areas dry to prevent bleeding.

Colors

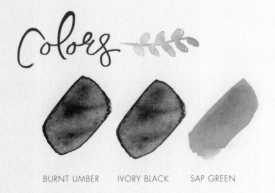

BURNT UMBER IVORY BLACK SAP GREEN

Supplies

- Round brush (size 6 works well)
- 3 colors of paint

1. Fill the entire belly of the bird with clean water until the paper is damp, but not soaking wet.

2. Add a small amount of diluted Burnt Umber directly to the wet area on the paper.

3. For the darker (right) side of the belly, add a touch more Burnt Umber pigment and allow the light and dark values to blend together. This is the magic of wet on wet!

4. Let that area sit for a few minutes until dry to the touch. Then, paint clean water to the black section of the bird, including the head, wing and tail.

5. Add diluted Ivory Black to the wet area and allow it to blend out. You can coax the color with your brush to get it where you want it.

6. Wet the leaves with water next and drop in Sap Green. When all the wet layers are dry to the touch, you can add the final details with the tip of your brush and more pigmented shades of your mixed colors!

feathers

These feathers are created with the wet-on-wet technique. This allows you to create some really unique blends, and it has a softer feel than wet-on-dry painting. For this painting, you'll experiment with blending colors and tilting your paper to help the paint fill out a shape.

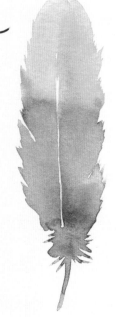

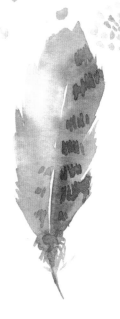

Colors

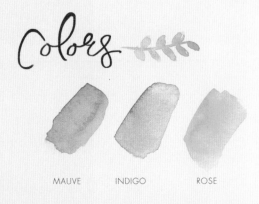

MAUVE INDIGO ROSE

Supplies

- Round brush (size 6 works well)
- 3 colors of paint

1. Working on one feather at at time, fill the entire feather area with clean water, leaving a small dry line down the center for the feather's stem. The paper should be damp and shiny.

2. While still wet, drop in your first color of choice with a brush at the bottom of the feather. Then, drop in another color at the top of the feather. This color will blend with the first to create a nice effect!

3. Tilt and tip the paper slowly to allow the paint to flow to the edges of the water-soaked areas. Don't worry, the paint will only go where the water has been placed!

4. With the fine tip of your brush, lightly drag out strokes around the edges with the wet paint to create a feathered look.

5. When your feather is dry to the touch, you can add additional details such as dots, spots and darker strokes using more pigmented mixes of your colors to create your own unique feather designs!

Maple Leaf

This leaf project will allow you to play around with mixing colors using the wet-on-wet technique.

You will also be able to create the veins in the leaf using a lifting technique and a dry brush. This method can be used for a variety of different objects!

Colors

INDIAN RED YELLOW OCHRE HOOKER'S DARK GREEN

Supplies

- Round pointed brush (size 6 works well)
- 3 colors of paint
- Paper towel

1. Fill in the entire maple leaf shape, except the stem, using clean water and your brush. The paper you fill should be damp and shiny, not soaked with puddles.

2. Starting at one side of the leaf, drop in some diluted Indian Red, followed by Yellow Ochre in the middle, and finally Hooker's Dark Green on the opposite side.

3. Allow the colors to blend together. You can coax them with your brush or tilt your paper to help the blending process along.

4. While the paint is still damp, dry your brush on a paper towel. Using the tip of the dry brush, run it along the vein lines to lift the color off. You may need to clean and dry your brush multiple times to lift off all of the veins.

5. Paint the stem with any of your chosen colors.

Snail

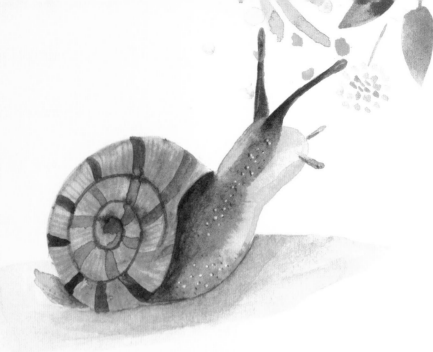

Slow and steady, this snail is a joy to paint! The spiral shape of its shell adds a little bit of whimsy to the piece, and can be decorated however you like.

By starting with a wet-on-wet technique, the base colors are able to create soft marbled effects with texture!

Colors

RAW UMBER BURNT UMBER YELLOW OCHRE HOOKER'S DARK GREEN

Supplies

- Round pointed brush (size 6 works well)
- 4 colors of paint + water
- Fine brush
- White gel pen

1. Start by mixing a ratio of 1:1 water and Raw Umber and apply it to the slug-like body of the snail.

2. While the area is still wet, add a stripe of Burnt Umber from the base of the tentacles to the shell and allow it to bleed into the previous color.

3. Darken the area where the body and shell meet using a more pigmented shade of Burnt Umber (very little water). Fill the tentacles with the same color and allow it to bleed into the wet strip.

4. When the painting has dried, fill the shell with a 1:1 ratio of Yellow Ochre and water. Add a bit of Raw Umber to the mix. Drop in touches of Burnt Umber wherever you like. Let dry completely.

5. Using a fine brush and Burnt Umber, paint the swirl onto the shell. With the same brush, create light lines using Burnt Umber around the spiral. Create thicker lines using the same color around the shell as well.

6. When the piece has dried completely, add small dots to the body with a white gel pen for texture and paint the leaf with Hooker's Dark Green!

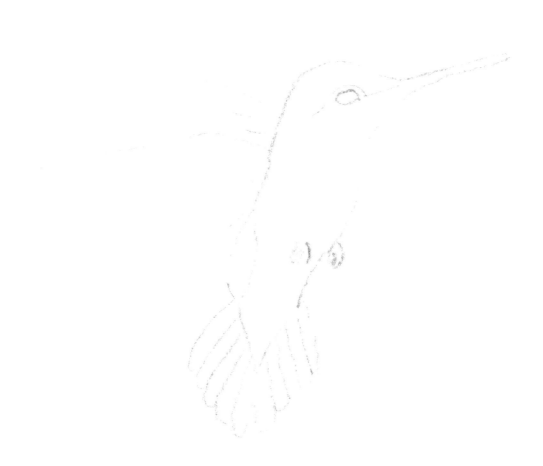

hummingbird

This hummingbird looks great using soft and delicate colors. Mixing a bit of Indigo with Hooker's Dark Green creates a subdued shade that can be used for the head and tail details, and creating a peach shade with Burnt Sienna and a touch of Indian Red goes a long way with extra water.

The wings are made to look transparent with a very watered-out version of the head-tail mix.

Colors

BURNT SIENNA INDIAN RED HOOKER'S DARK GREEN INDIGO

Supplies

- Round brush (size 6 works well)
- 4 colors of paint

1. Fill the entire peach body area of the bird with clean water until the paper is shiny. Add a touch of your mixed peach (Burnt Sienna and Indian Red) color to the wet area and allow it to spread out.

2. Using a slightly darker tone of that same peach color (less water), create some dimension by adding a little to the left-hand side to darken it.

3. Let this dry for a few minutes. Then, do the same for the head and tail areas, wetting the paper first and then dropping in Hooker's Dark Green mixed with Indigo. Be sure to use a light touch and the tip of the brush to drag the beak out to a point.

4. Create the wings by mixing a very light, almost clear shade of Indigo and quickly sweeping the brush from the top to the bottom of the wings. Drop in some of your peach color to the top of the strokes for extra detail, and let it spread out.

5. Once bone dry, add the spotted details on the neck with your blue-green mix, then complete the feet and eyeball.

bluebird

This sweet little bluebird is created using muted and watery colors. Peach is made by mixing Indian Red and Burnt Sienna with lots of water for a subtle look. The base is created using a wet-on-wet technique, while the final layer will be done using a wet-on-dry technique to add details. You can use a black ink pen for the eyeball detail and beak.

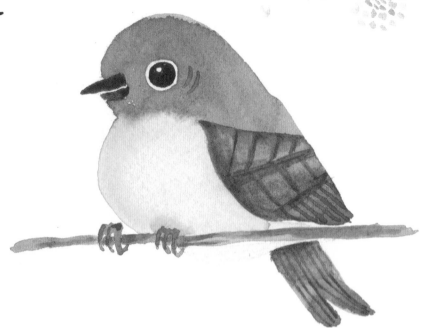

Colors

INDIAN RED BURNT SIENNA INDIGO BURNT UMBER

Supplies

- Round brush (size 6 works well)
- 4 colors of paint
- Black ink pen

1. Fill the entire body of the bird with water so the paper is nice and damp.

2. Add a light amount of the Burnt Sienna and Indian Red peach mixture to the belly area.

3. Before the peach fully dries, add Indigo to the damp head area, excluding the wing. Be sure to leave the eye area dry. The colors should blend together where they meet under the neck.

4. Once that first layer is dry to the touch, wet the remaining wing area and tail again and drop in Indigo once more.

5. Let your paint dry for a few minutes. Add the lines and details in the wing and tail using a more pigmented Indigo mix. Fill in the beak with this same color.

6. Complete your bird by adding Burnt Umber to the branch and Burnt Sienna to the feet. You can use a black ink pen for the eyeball.

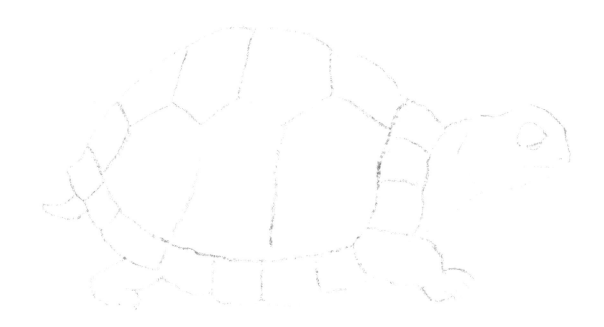

tortoise

The shell of a tortoise has many different shades of colors and texture details. In this painting, you will create a shell with multiple marbled sections for a totally unique look. You never know what you're going to get when you start dropping colors into wet areas!

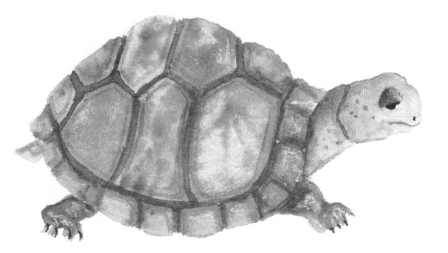

Colors

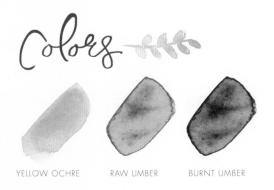

YELLOW OCHRE RAW UMBER BURNT UMBER

Supplies

- Round brush (size 6 works well)
- 3 colors of paint
- Detail brush

1. Wet each section of the shell so the paper is shiny and damp, making sure to leave thin spaces of dry paper in between each section. You don't want the paint to bleed into the section beside the one you are working on.

2. Drop in some Yellow Ochre to each wet section. Then, carefully add Raw Umber droplets as if you were using a syringe for each drop. You can use the tip of your brush to drag the color around.

3. Once that layer is dry to the touch, outline each shell section with Burnt Umber using the tip of your brush.

4. Wet the head area, and add a light wash of Raw Umber mixed with Yellow Ochre. Add Burnt Umber as a shadow on the neck around the shell. Do the same for the legs and tail.

5. When you're finished, you can add the details to the face, feet and claws with a thin brush and Burnt Umber.

Squirrel

This colorful squirrel is created by painting the tail portion first, and then moving on to the body. The color blends in this one are important, and layering is also used to help define some of the shapes of the squirrel.

Adding in an unusual color, such as Mauve, can give this piece a surreal effect!

Colors

BURNT SIENNA RAW UMBER MAUVE BURNT UMBER

Supplies

- Round brushes (sizes 10 and 6 work well)
- 4 colors of paint
- Fine tipped ink pen

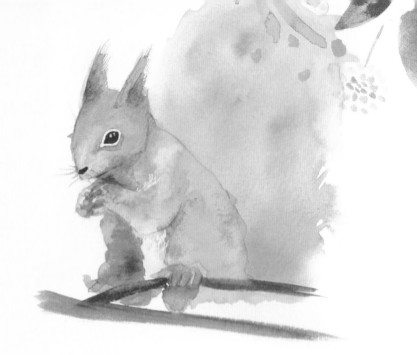

1. Start by creating the shape of the tail using clean water on the paper with a large brush. This doesn't have to be perfect!

2. Start dropping in Burnt Sienna, Raw Umber and Mauve on the wet surface, and allow them to blend together.

3. Wait a few minutes until the tail is totally dry, then wet the body of the squirrel with water, leaving the white belly and eye areas dry. Start dropping in Raw Umber, Burnt Sienna and Burnt Umber. Try to concentrate the darker shades in areas where shadows would form, such as the leg on the left.

4. As your paper dries, you can start defining the neck, hands, arms, feet and ears using a smaller brush. Darken those areas using Burnt Umber to add shadow and create crisp edges.

5. Drag the tip of your brush out on the ears using short strokes to create fur.

6. When your piece is dry, continue to define the hands, face, ears and legs using light mixes of color. Layer them until you are happy.

7. Add the eye and nose details using a black ink pen.

leaves

This leaf project is similar to the way you painted the Maple Leaf (page 43). However, instead of working with the paint totally wet, you're going to let it dry and add in the vein details.

The colors can range from greens to autumn hues, and the possibilities are really endless!

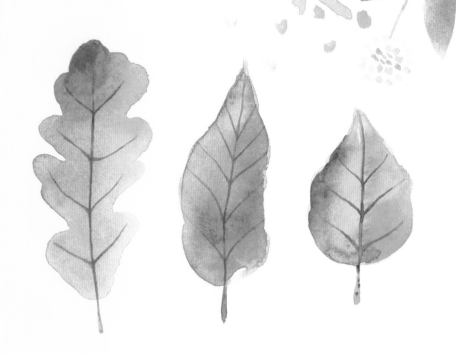

Colors

HOOKER'S DARK GREEN RAW UMBER INDIAN RED BURNT UMBER

Supplies

- Round pointed brush (size 6 works well)
- 4 colors of paint
- Fine detail brush

1. Fill in the first leaf with a watery wash of Hooker's Dark Green. The paper should be visibly wet to allow the following colors to blend.

2. Drop in a second color of your choice, and let them blend. Add another color, and continue until you're happy with how it looks. You can coax the colors together lightly with your brush or tilt your paper to speed it up.

3. Move on to your second leaf while you wait for the first to completely dry. Using the same technique, fill the leaf with a color of your choice, making sure it is visibly wet. Drop in your other colors, and let them blend.

4. For the third leaf, do the same thing. When all three leaves have dried completely to the touch, paint in the veins and stem with Burnt Umber and a fine detail brush. Press lightly and use the very tip of the brush to get nice, thin lines.

wild roses

These flowers are done in a very loose style, so don't worry about details or making the shapes perfect. Instead, the shapes should be suggested with the colors. Attempting this piece with a loose hand will help you splash on the paint with less control. Let the edges bleed, and the colors run into one another.

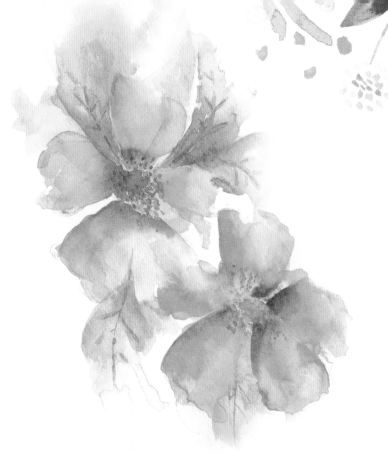

Colors

ROSE MAUVE HOOKER'S DARK GREEN YELLOW OCHRE

Supplies

- Large round brush (size 12 works well)
- 4 colors of paint
- Smaller round brush (size 3 works well)

1. Using the sketched outlines as a guide only, splash on some clean water to the petals in a loose fashion to wet the paper. It should be shiny and visibly wet.

2. Add Rose and Mauve to the wet petals. Then, add a darker (less water) Mauve to the center portions and let the colors blend together.

3. Loosely paint the leaves with a mix of Hooker's Dark Green and Yellow Ochre without wetting the paper first. Don't worry if the petals bleed into them! With clean water on your brush, you can gently touch the edges of the leaves to blend them out.

4. Add Yellow Ochre to the centers of the flowers, and finish with pollen dots and leaf veins using a more pigmented green mix.

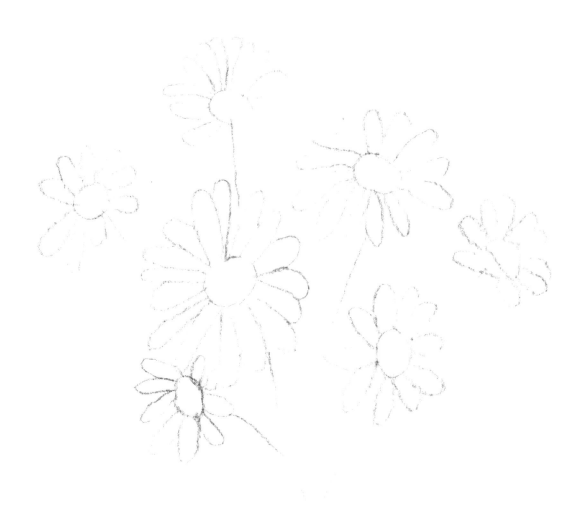

Daisies

For this painting, you will need masking fluid to create the white daisies. Masking fluid is a liquid latex solution that you can apply to any areas that you wish to stay free from paint. It peels off when your work is dry to reveal the white paper underneath. Apply it with an old brush, or try using a masking fluid pen.

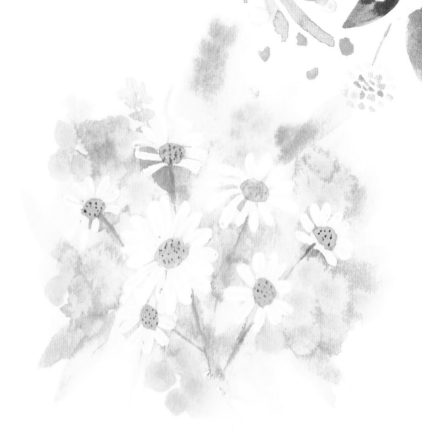

Colors

HOOKER'S DARK GREEN MEDIUM YELLOW YELLOW OCHRE

Supplies

- Masking fluid
- Large brush (size 10 works well)
- 3 colors of paint

1. Fill all of the white petals with masking fluid and let it dry. It should be completely dry to the touch before you paint.

2. Wet the whole paper with water and start loosely dropping in the green background colors. You can mix Hooker's Dark Green with the yellow colors to create different shades.

3. Using your brush in the wet paint, create some indications of leaves sticking out from the edges.

4. Dot some Medium Yellow onto the green background to create clusters of spots.

5. Let the piece fully dry for half an hour, and then remove the masking fluid with an eraser to uncover the white petals.

6. Paint the centers of the flowers with Yellow Ochre as well as the stems with your green mixture. Add dot detailing to the centers once dry using a mix of green and yellow.

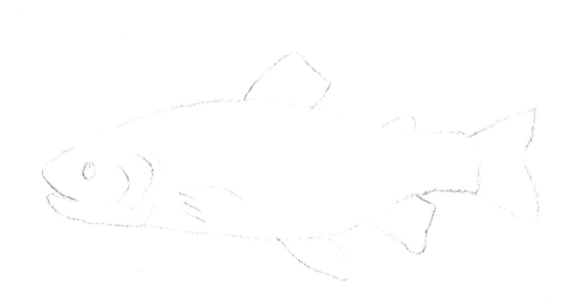

trout

Fish are so much fun to paint! The body of this trout is created using the wet-on-wet technique, followed by a wet-on-dry layer for detailing. The gradient through the middle is what should be the focus of the wet painting. The details are added with a fine detail brush once the body is dry.

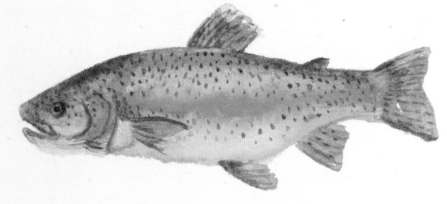

Colors

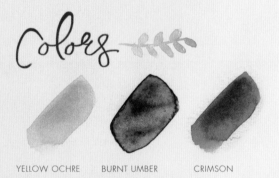

YELLOW OCHRE BURNT UMBER CRIMSON

Supplies

— Round brush (size 6 works well)

— 3 colors of paint

— Fine detail brush

1. Fill the entire body of the fish—excluding the fins—with water using your brush so the paper is damp and shiny.

2. Add a mix of Yellow Ochre and a touch of Burnt Umber to the top portion of the body, followed by a stripe of Crimson directly below it. Allow the colors to blend. You can darken the top of the head with Burnt Umber.

3. Add a very light mix of Yellow Ochre to the bottom edge of the wet belly area and allow the color to blend upwards. The three "stripes" of color should bleed together to create a nice gradient. Allow the body to dry for a few minutes.

4. Fill the fins with water and then drop in the yellow-brown mix you created previously to fill them in.

5. After the piece has dried, add spots, facial details, eye, gills, and lines to the fins with a fine detail brush and Burnt Umber.

try it →

FILL WITH BASE COLOR **ADD MIDTONE STROKES** **ADD DARK STROKES**

PAINTING FUR

There are many ways to paint fur, but in this book I want to share some of my favorite methods. In the following projects, you'll use the wet-on-dry and wet-on-wet skills you learned earlier to paint some pretty cute critters!

Most of these paintings are done using a similar technique, which involves short strokes, thin brushes, and lots of layering. The layering is really what makes the fur come to life and look a little less two-dimensional. By starting with light tones and building up to darker ones, shadows and highlights can be made easily.

I recommend using brushes ranging from sizes 2 to 3, as well as a fine detail brush for the furry strokes.

Practice your strokes using the page to the left. Start by filling in the object with a light wash of color. Mixing just a little bit of pigment with water will give you a nice light base to start with.

Once that layer has dried, start filling in the area with short, fine strokes. Try your different brush sizes to see what feels most comfortable for you. The first layer of brush strokes should be more of a mid tone.

After that layer has dried, go in again with the same brush and a darker tone. Concentrate this dark tone on the bottom half to give the object a bit of a shadow effect.

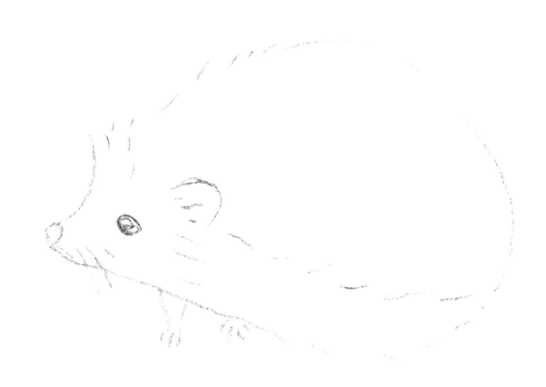

hedgehog

Although it doesn't technically have fur, a hedgehog still has a lot of texture that we can re-create using the fur-painting technique.

For this piece, you will start out with a very light wash as a base and slowly build up the darker tones using small strokes. Leaving white space on the paper will create the white details.

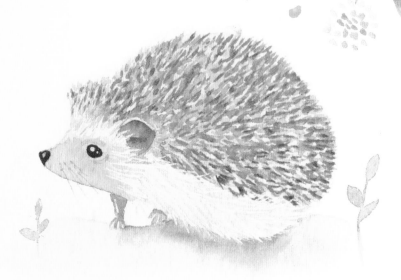

Colors

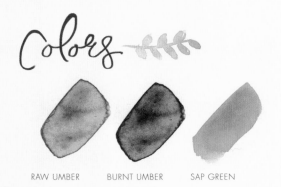

RAW UMBER BURNT UMBER SAP GREEN

Supplies

- Round brush (size 6 works well)
- 2 colors of paint
- Fine detail brush
- Black Pen
- White paint

1. Paint a very light base of water mixed with a tiny bit of Raw Umber pigment over the entire hedgehog.

2. Once dry to the touch, add another layer of the same wash to the face to build the darker detailing as shown in the example.

3. Pull the brush outwards to create sweeping hair detail around the face and area where the body meets the spikes. Paint the ear and feet with Burnt Umber.

4. Using a mix of Burnt Umber, Raw Umber and water, create a midtone brown. Fill the upper body with small strokes to replicate spikes, being sure to leave white areas exposed for highlights.

5. Once that layer has dried completely, add a final layer of a more pigmented Burnt Umber to the upper body.

6. Finish the details in the face with a black pen and fine detail brush. Paint the whiskers with a fine brush and Burnt Umber. You can also add some very thin white strokes with white paint to the body for highlights.

7. Using the Sap Green, add little sprouts and the indication of grass below the hedgehog.

Bumblebee

This bumblebee is created using short strokes and white highlights. The consistency of paint should be rather opaque, so you will use only a small amount of water to activate your colors. The furry and finer details will require a small detail brush for maximum impact.

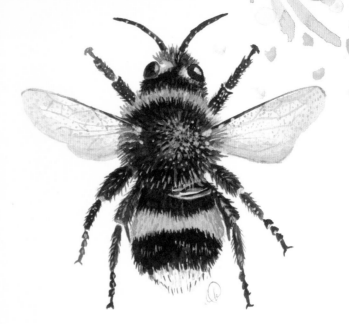

Colors

IVORY BLACK YELLOW OCHRE RAW UMBER

Supplies

- Round brush (size 6 works well)
- 3 colors of paint + white paint
- Detail brush

1. Fill the upper body circle with Ivory Black. Use a dry brush to remove some paint to form a light spot in the center. Let dry completely.

2. Using small strokes, a detail brush, and a darker mix of Ivory Black, fill the painted upper body with "furry" short lines following the radius of the circle.

3. Complete the lower body stripes using small black strokes, and then paint the head, leaving the eye area untouched.

4. Once the black has dried after a few minutes, add the bee's yellow stripes using Yellow Ochre with the same small stroke motion and detail brush.

5. Fill in the antenna, eyes and legs. Drag out small strokes from the edges of the legs for a furry look using the dry detail brush.

6. Using more water with the yellow paint for a transparent wash, fill in the wings. Let dry, and add the wing details and veins with the detail brush and a wet mix of Raw Umber paint.

7. Finish the piece with opaque white paint, adding small strokes to highlight the eyes and fur all over the bee's body!

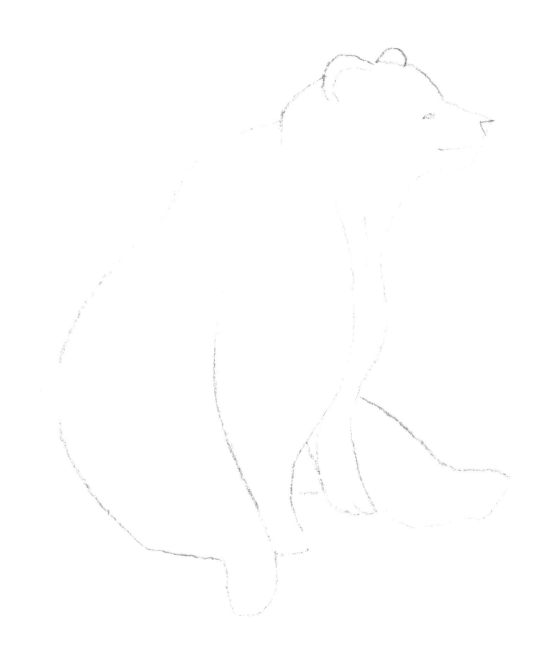

Bear

A bear is basically a big old ball of fur, so in this painting you'll focus on making darker shadows by layering strokes, and changing the direction of the strokes to match the bear's sitting position.

Raw Umber will be used as a midtone while Burnt Umber and Ivory Black will be used to darken the fur and shadow areas.

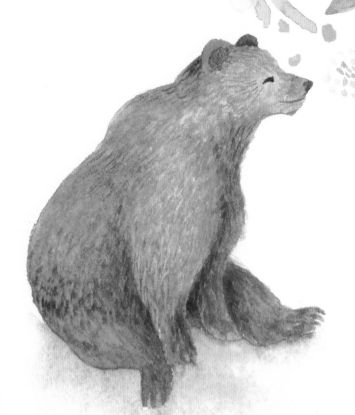

Colors

RAW UMBER BURNT UMBER IVORY BLACK

Supplies

- Round pointed brush (size 2 works well)
- 3 colors of paint

1. Start by creating a base for the bear's fur. Paint the entire body with a light wash of Raw Umber, adding in drops of Burnt Umber in the darker shadow areas such as behind the front legs, the back thigh, chest, right leg, and top of the head while the paint is still wet.

2. When that layer is dry, use your brush tip and a 1:1 ratio of Raw Umber and water to create fine, short strokes following the body of the bear.

3. Let the first layer of fur dry. Build up your next layer using a light mix of Burnt Umber, concentrating the fur strokes in the darker shadow areas such as behind the legs, ears, and on the neck.

4. Let dry and then add even darker strokes with Ivory Black on top of the shadow areas you created previously. Complete the facial features with Ivory Black and the tip of your brush. Add Burnt Umber to the inside of the ears.

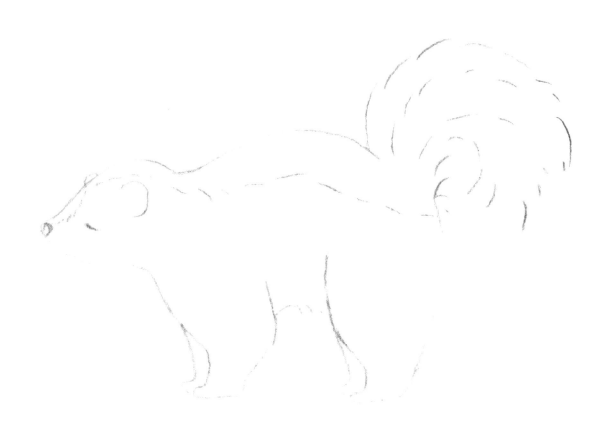

Skunk

The entire body of this skunk is created using just one color: Ivory Black. The different light and dark values are done by adding more or less water to the paint pigment.

The facial details can be done using a fine-tipped black ink pen at the end.

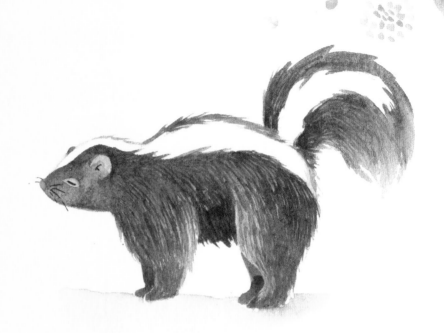

Colors

IVORY BLACK ROSE

Supplies

- Round brush (size 6 works well)
- 2 colors of paint
- Detail brush
- Fine tipped black ink pen

1. Create a base layer for the skunk by filling in the entire black area of the body with a very light wash of Ivory Black and water. It should dry as a very light grey.

2. Once the base layer is down and totally dry, start creating longer, thin strokes with a detail brush and slightly darker shade of grey. Be sure to leave the white areas untouched.

3. Add another layer of furry strokes using a darker shade of the black to define the shadow detail behind the ear, stomach, legs, and base of the tail. Leaving some areas untouched on the darker layers will allow highlights to form, such as around the legs.

4. Finish by adding a touch of Rose to the nose and completing the facial details with your fine tipped pen.

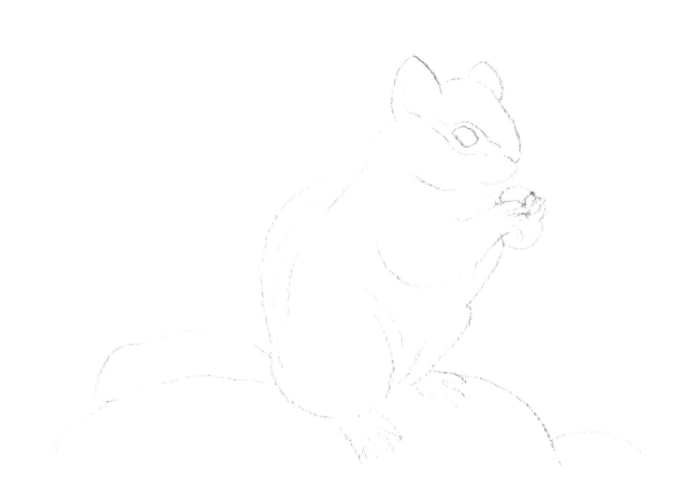

Chipmunk

This little chipmunk is painted with short brush strokes and a layer of highlights to make the strokes appear to blend together. This gives the piece a more textured look.

The brush size is slightly larger than the detail brush used for many of the other paintings.

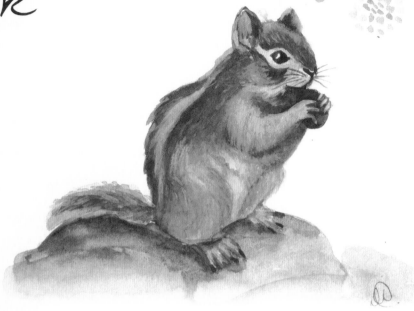

Colors

RAW UMBER BURNT UMBER IVORY BLACK

Supplies

- Round pointed brush (size 2 works well)
- 3 colors of paint + white paint
- Round brush (size 6–8)

1. First paint the base layer of your chipmunk with a light wash of Raw Umber.

2. With that layer dry, use your smaller brush to loosely paint in the fur with single strokes. Use a lighter mix of color for highlighted areas and darken the shadows with Burnt Umber strokes.

3. Once that is totally dry, continue to darken areas such as the back, feet, ears, and under the arms and neck with a little Ivory Black. Add the acorn with Burnt Umber.

4. Using a pigmented white paint, add the highlighted areas on the tail, legs, around the eye, face, and feet, as well as the stripe on his back in the same stroke motion.

5. Paint the rock loosely using the wet-on-dry method with Ivory Black, making it darker underneath the chipmunk for a shadow effect.

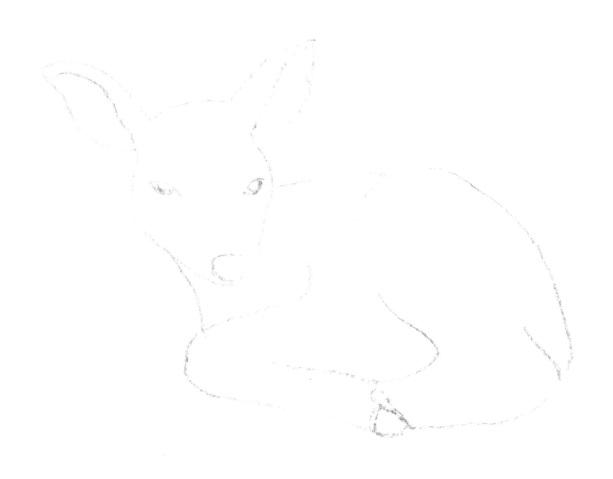

fawn

This fawn is created by layering different shades of Raw Umber and Burnt Umber with lots of fine, short strokes. The white detailing is done afterwards using either a white ink pen or a more opaque paint such as acrylic or gouache. By changing the direction of your strokes, you can follow the curves of the body for a more realistic feel.

Colors

RAW UMBER BURNT UMBER INDIAN RED

Supplies

- Round brush (size 6 works well)
- 3 colors of paint
- White pen
- Fine detail brush
- Black ink pen

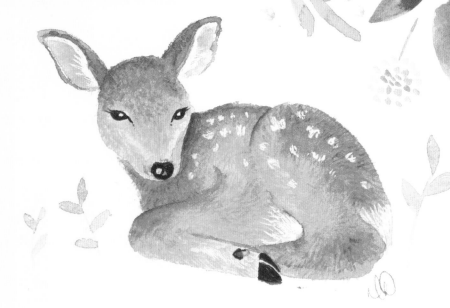

1. Start by filling in the entire body of the fawn with a light wash of Raw Umber. It should resemble a light beige. Do not make this layer too dark as it will just be the base for the darker shades.

2. While that wash is still wet, you can drop in some Burnt Umber to the darker areas of the fawn such as under the neck, back leg, and the top of the head to create shadows.

3. Once your base layer is dry, start creating fine, short strokes with a fine detail brush. The first layer of "fur" should be more of a midtone Raw Umber. Fill the ears with a very light wash of Indian Red for a pink hue.

4. As the first layer dries, start adding in a second layer of more pigmented paint the same way you just did. Remember to change the direction of the strokes with the bends of the body.

5. Continue building up your short stroke layers until you are happy with how it looks. Two to three layers should work nicely. Add more strokes using Burnt Umber to the shadow areas you painted previously to make them even darker.

6. Finish by adding white spots and highlights to the ears, tail, and body using a white pen, then use a black pen for the black details such as the feet, eyes and nose.

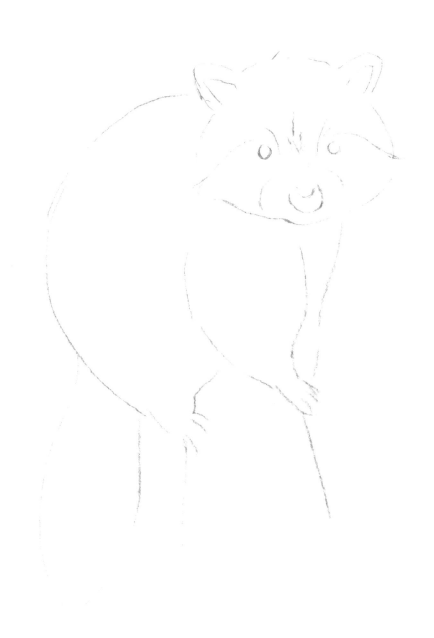

Raccoon

No forest would be complete without a not-so-innocent raccoon!

Using dark shades of paint and lots of fine strokes and layers, the character of this little masked bandit will start to emerge. Keep the contrast of the dark and light features in his face in mind when painting, and don't cover up those white areas!

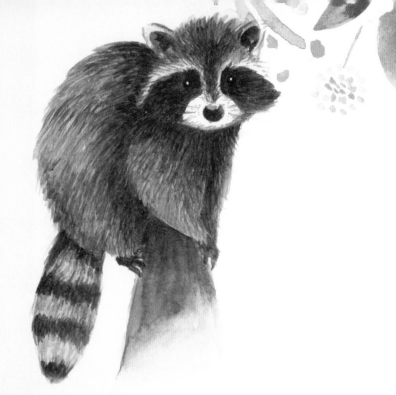

Colors

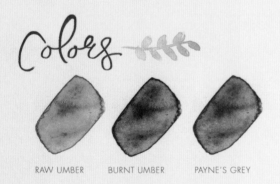

RAW UMBER BURNT UMBER PAYNE'S GREY

Supplies

- Round brush (size 6 works well)
- 3 colors of paint
- Black ink pen
- Fine detail brush

1. Paint the entire body of the raccoon using a ratio of 1:1 Raw Umber paint and water. Do not paint the head. This will be your base color.

2. After a few minutes it should be totally dry. Start to add short, dense strokes of Burnt Umber to the body around the arm and head/neck area to build up a shadow, making sure to follow the direction of the body.

3. Let the paint dry. Then go back in with the same color, creating strokes throughout the whole body, tail, and arm. Add Payne's Grey strokes to darken the fur and fill the body even more.

4. Fill in the mask, ears, nose and tail stripes with Payne's Grey. You may need several layers to get it dark enough.

5. Use short, upward strokes of Burnt Umber and Payne's Grey on the top of the head, leaving the area above the mask white.

6. Finish by making little circle eyes with a black pen, leaving a small white dot in each.

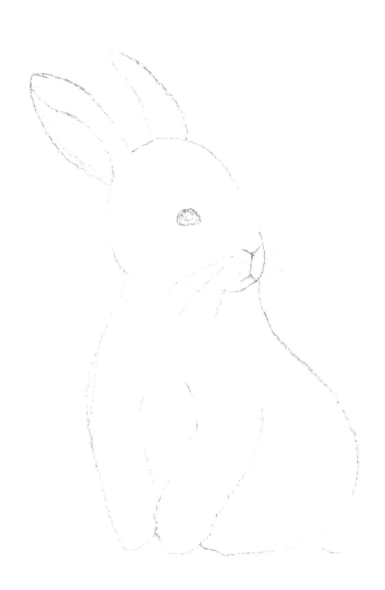

rabbit

With this rabbit, you'll see how you can create a fur effect using a white accent tool, such as a white gel pen. The white accents are applied after the entire painting is completed, and they really help to bring the piece to life with highlights. Here, the white was also used around the eye and ears for more dimension. If you want to, you can also use a fine detail brush and white gouache instead of a pen.

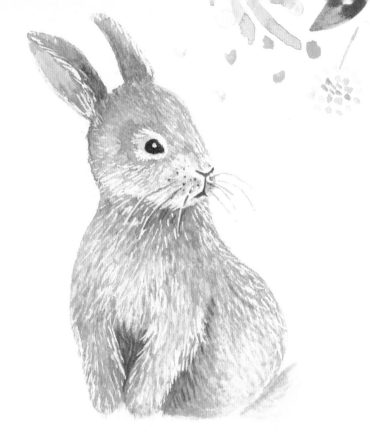

Colors

RAW UMBER BURNT UMBER INDIAN RED IVORY BLACK

Supplies

- Round brush (size 6 works well)
- 3 colors of paint
- White gel pen
- Fine detail brush

1. Start by filling the entire body of the rabbit with a light wash of Raw Umber. Add in Burnt Umber wherever you want shadows to appear, such as under the chin and around the feet.

2. When that layer is dry to the touch, fill the rabbit with short strokes of a darker (less water) Raw Umber and Burnt Umber mix, being sure to place the strokes in the direction of fur growth on the body.

3. Add a third layer of the same color mix using the same technique. The layering of the same shade will darken the color.

4. Add a light wash of Indian Red to the ear.

5. Using your white pen, add strokes all over the rabbit as shown in the example.

6. Finish details such as the eye, nose and whiskers with a fine detail brush and Ivory Black paint.

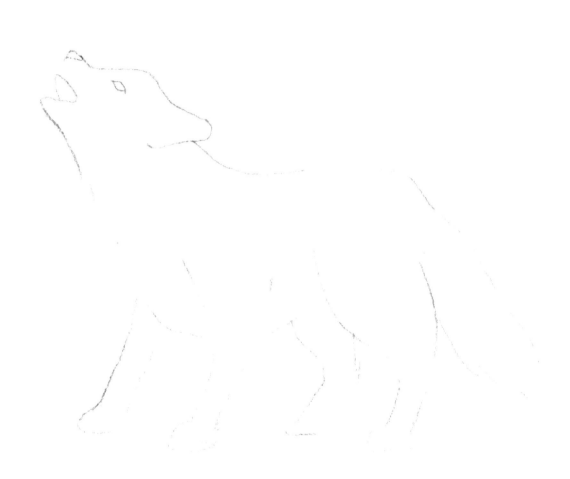

Coyote

Painting fur can also be done using a wet-on-wet technique. This coyote is painted by wetting the paper first and adding color to the wet areas. The texture of the fur is created by simply wiggling your brush in a vertical stripe-like pattern and layering the colors as you go.

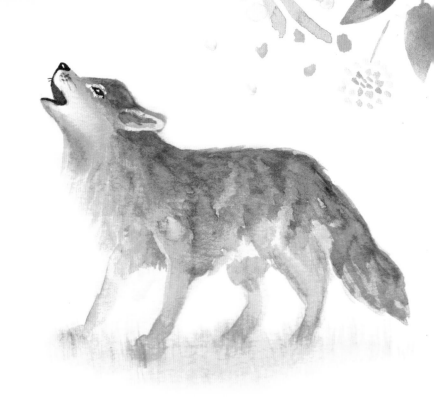

Colors

RAW UMBER BURNT UMBER IVORY BLACK

Supplies

- Round brush (size 6 works well)
- 3 colors of paint
- Fine tip brush (optional)
- Black pen (optional)

1. Start by wetting the entire body of the coyote with clean water using your brush.

2. While the paper is still damp, paint on your lightest brown color (Raw Umber) to create a base.

3. While the paint is still damp, add a darker shade of Burnt Umber to areas under the chin, legs, and top of the head.

4. As your paint starts to dry, alternate the Raw Umber and Burnt Umber colors while creating wiggly, whispy strokes down the body in the direction that the fur would grow.

5. When the paint is dry, finish the facial details with either a black pen or Ivory Black on a fine tip brush.

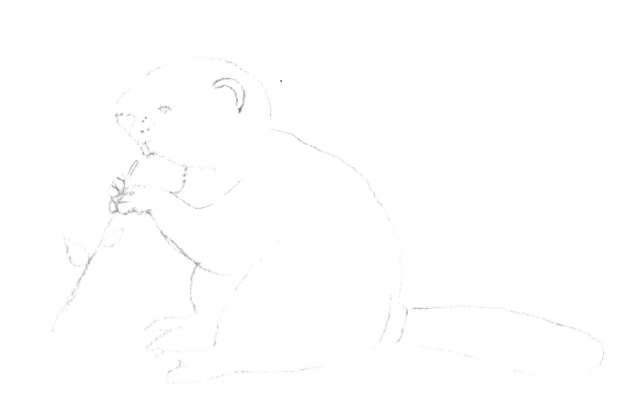

Beaver

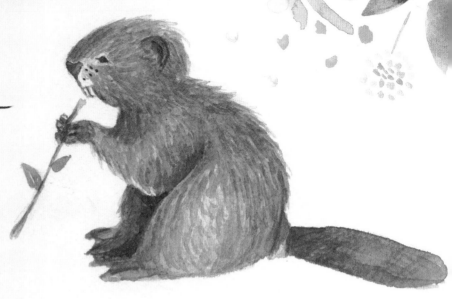

Using various shades of brown, this beaver comes to life!

Mixing the three colors below in different combinations will allow you to experiment with different shades and tones. This painting uses a few mixes of colors to really get that layered fur look.

Colors

RAW UMBER BURNT UMBER IVORY BLACK

Supplies

- Round brush (size 6 works well)
- 3 colors of paint
- Fine detail brush

1. Fill the entire body with a light wash of Raw Umber to create your base.

2. After a few minutes when that layer is dry, use the tip of your brush to create little strokes all over the body using a more pigmented mix of Raw Umber.

3. Once that layer has dried, create another layer of fine strokes, but this time try using Burnt Umber.

4. Add darker strokes of Burnt Umber and Ivory Black to the shaded areas such as under the neck, the back leg, hands, ear, and tail. Try to limit the amount of paint you add to the highlighted areas.

5. Using Burnt Umber, a bit of Ivory Black, and water, paint the tail. When it has dried, create a light crosshatching effect on top with Ivory Black for texture.

6. Finish by painting on the small details in the face and feet with a fine brush and Ivory Black.

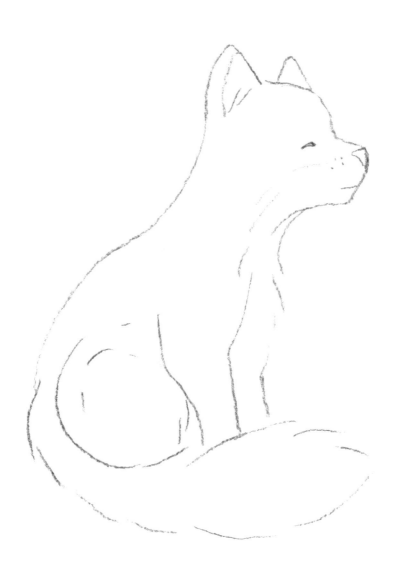

Fox

A sly little fox is always fun to paint with its big bushy tail and wispy fur. Leaving the white areas untouched will allow the paper to become part of the painting.

Keep the direction of the fur in mind, and use longer strokes around the edges to soften it up.

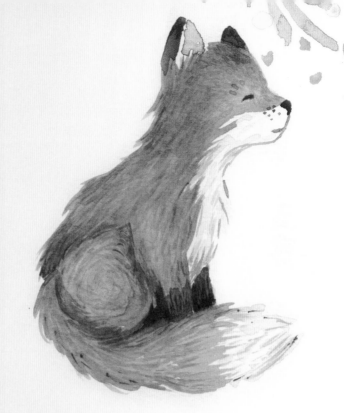

Colors

BURNT SIENNA BURNT UMBER IVORY BLACK

Supplies

- Round brush (size 6 works well)
- 3 colors of paint
- Detail brush
- Black ink pen (optional)

1. Apply a light wash of Burnt Sienna to the body of the fox, leaving the white areas untouched. This will be your base.

2. Let the first layer dry completely and using a slightly more pigmented mix of Burnt Sienna, create fine brush strokes over the base color. Paint thin, wispy lines with the same color down the right side of the white chest to separate it from your paper.

3. Alternate pigmented shades of Burnt Sienna and Burnt Umber in the same stroke motion to increase the intensity of your layers and darken the shadows around the head, base of tail, and legs.

4. Create fine wisps of fur using Burnt Sienna and Burnt Umber around the body using light strokes and a detail brush.

5. Paint the bottoms of the feet and tips of the ears using Burnt Umber.

6. Add the facial details with a pen or Ivory Black when the body is dry.

try it

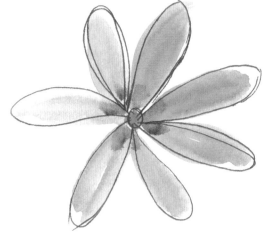

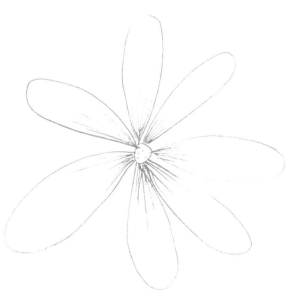

SKETCH YOUR OWN

INK AND WASH

Ink and wash (also called line and wash) is the process of sketching out your subject in ink before applying quick and light washes of color to it.

A lot of artists use this technique "en plein air" (outdoors) so they can quickly sketch their subject in the moment.

I love when ink-and-wash pieces have a rushed look to them, so I normally try to keep my line work a little sketchy and my color application imperfect. That means it's totally okay to go outside of the lines!

With ink and wash, you're mostly implying where the colors should appear as opposed to being super detailed with it.

You will need a permanent ink pen or marker for the next exercises. Always test your pen first to make sure it won't bleed when you touch water to it! You can do this on a scrap piece of paper by doodling some marks, letting it dry, and then brushing some water over it.

My favorite pens to use are the Pigma Micron pens and the Tombow Fudenosuke pens.

Let's try it before diving in.

On the left, sketch over the template lines with your pen. Try to keep your lines sketchy— it's more fun! Then, with light washes of mixed paint, blot, brush, and dab it onto the areas you want to color. It's okay to leave white space!

dragonfly

Although it's fairly simple, this project will help to introduce you to the concept of ink and wash.

The ink work is done first, followed by the quick washes of color. Don't be afraid of going outside of the lines as that is what adds some interest to ink and wash!

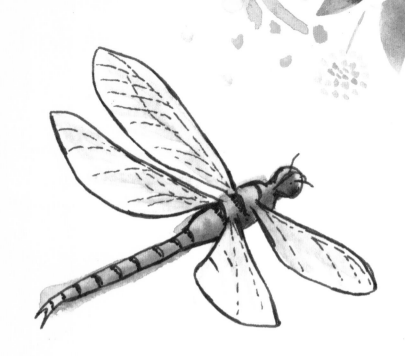

Colors

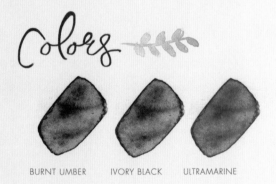

BURNT UMBER IVORY BLACK ULTRAMARINE

Supplies

- Black permanent ink pens (size 5 + 1)
- Round brush
- 3 colors of paint

1. Sketch over the outline of the dragonfly on the opposite page using a size 5 ink pen.

2. Complete the interior details using broken, sketchy lines and a smaller pen (such as size 1).

3. Mix up some water with a touch of Burnt Umber. Apply it to the body of the insect, right on top of that ink work you did previously.

4. With that layer still wet, take a darker pigment of Burnt Umber and run it along the bottom half of the body.

5. Mix water with a tiny bit of Ivory Black and a touch of Ultramarine to create a really light shade of blue-grey. Apply this to the wings in quick stroke motions, following the ink lines you sketched.

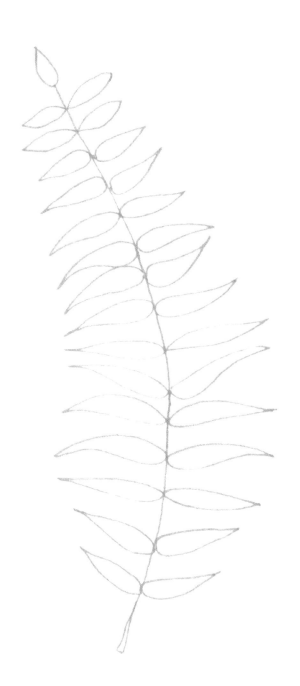

mountain ash leaf

Let your imagination run wild with the colors in this piece!

Various wet-on-wet washes make each leaflet have a bit of personality and give the leaf a quirky boho vibe.

Colors

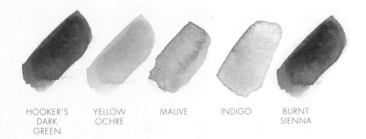

HOOKER'S DARK GREEN	YELLOW OCHRE	MAUVE	INDIGO	BURNT SIENNA

Supplies

- Black permanent ink pen
- Round pointed brush (size 6)
- Various colors of paint

1. Start by filling in the line work in the sketch with a black ink pen or marker.

2. With a color of your choice mixed with water, dot one of the leaves using the shape of your brush tip.

3. Add another dab of a different color to the same leaf and let the colors blend together.

4. Continue this method for each leaf, alternating colors and coming up with unique pairings of paint all the way down.

Stoat

This little weasel is painted using just two colors and diluting the pigment to create lighter washes. Using sharp and short strokes, you can create a loose representation of fur on the body. A finer tipped pen is used for the whiskers and facial details.

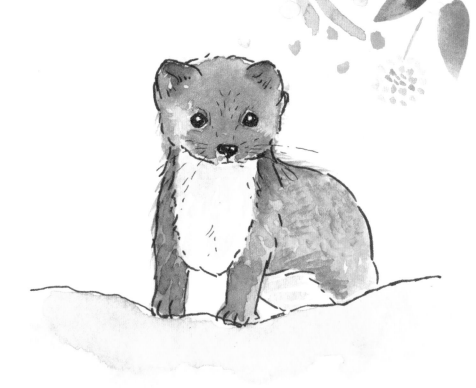

Colors

BURNT UMBER HOOKER'S DARK GREEN SAP GREEN

Supplies

- Round brush
- 3 colors of paint
- Black permanent ink pens (size 3 + 1)

1. Using a permanent ink pen in size 3, complete the outline of the stoat. Keep the lines sketchy and broken.

2. Fill the body using a light wash of Burnt Umber, avoiding the white chest and belly areas.

3. Once the first layer is dry, add another layer using short, loose strokes and a darker mix of the Burnt Umber mix to create the fur effect.

4. Lightly brush on some very diluted Burnt Umber to the chest to give a slight indication of shadow under the neck and behind the front leg.

5. Complete the critter using a size 1 pen on the facial details and whiskers.

6. Add an indication of grass on the ground using Sap Green.

Salamander

This salamander will help you become a little more familiar with adding details with a permanent ink pen.

Although the rock is a single solid color, adding little line and dot details help to indicate the texture of the object.

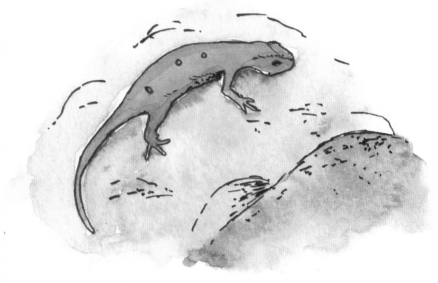

Colors

BURNT UMBER BURNT SIENNA

Supplies

- Round brush (size 6)
- 2 colors of paint
- Black permanent ink pen (size 3)

1. Start by adding the background rock color to the paper. A light and quick wash of Burnt Umber works well.

2. Once dry to the touch, outline the salamander using your black pen, and add the internal details.

3. Fill the salamander with a mix of Burnt Sienna, and let dry.

4. Add another layer of the same Burnt Sienna mix to areas requiring a bit of shadow, such as the belly, top of the body, and head.

5. Finish by adding details and sketchy lines to the rock for texture using your ink pen.

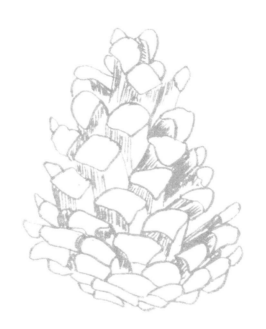

pinecone

Pinecones are great to use in illustrated holiday cards and winter-themed pieces!

The main body of this pinecone is created using an ink sketch, followed by some simple brushwork for the greenery. Try to leave some white space when painting the pinecone to give the impression of loose highlights.

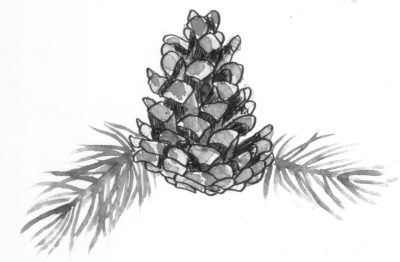

Colors

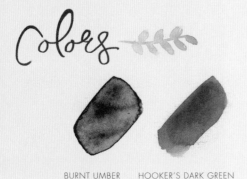

BURNT UMBER HOOKER'S DARK GREEN

Supplies

- Round pointed brush (size 3)
- Detail brush
- 2 colors of paint
- Black permanent ink pen (size 3)

1. Using the sketch outline on the left, trace over the lines of the pinecone with a permanent ink pen. Include the shading portions by sketching or crosshatching lines on the darker areas.

2. With a light mix of Burnt Umber, begin loosely filling in the pinecone.

3. When that layer is totally dry, dab on darker areas of Burnt Umber to help create dimension. Paint this color over the shadow areas and on some of the tips.

4. Using a fine detail brush, draw the center stems of the pine needles using Burnt Umber, then gently sweep out long, semi-curved clustered lines of Hooker's Dark Green for the needles themselves.

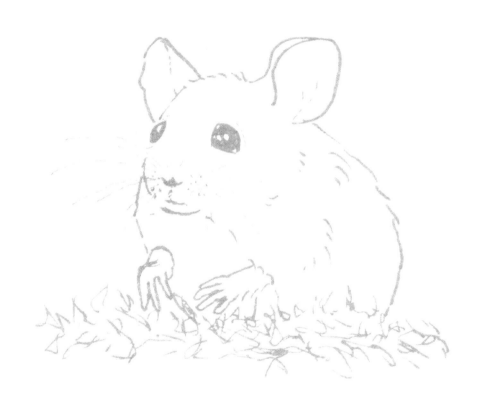

mouse

Small but mighty cute, this little mouse uses quick washes of color and two pen sizes to complete. The outlines are kept sketchy and squiggly, and little pops of pink help to brighten him up! Keeping some of the lines broken around the body also helps give the impression of fur.

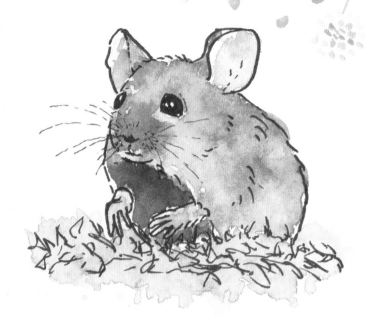

Colors

BURNT UMBER ROSE HOOKER'S DARK GREEN

Supplies

- Round brush (size 6)
- 3 colors of paint
- Black permanent ink pens (size 1 + 5)

1. Start by creating the sketched outline of the mouse using your size 5 permanent ink pen. Keep some of the outside lines sketchy and broken to give the indication of fur.

2. Add a few detail lines to the body to indicate the direction of the fur.

3. Using squiggly strokes, fill in the grassy area with the same pen.

4. With a finer tipped pen (size 1), add in the whiskers and spots on the face. Keeping some of the lines broken helps to make the whiskers appear as if they're catching a little bit of light.

5. Wet the mouse with clean water and add a touch of Burnt Umber. Let it spread out; you can coax it with your brush. Then, add some darker drops around the nose and on the belly.

6. Once your paper is dry, finish by adding touches of Rose to the ears and hands.

7. Using Hooker's Dark Green, add some color to the ground.

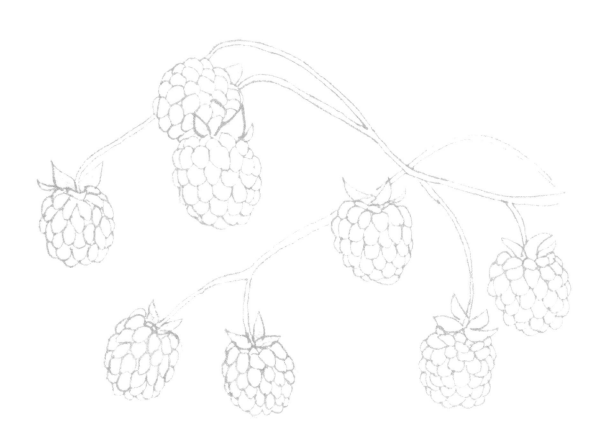

raspberries

In this piece you will create a background wash behind the raspberries using the wet-on-wet technique.

The berries and vine are then colored loosely. Disregard the outlines and leave bits of white space.

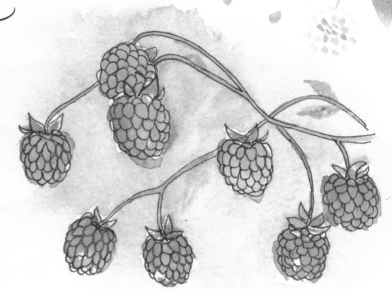

Colors

HOOKER'S DARK GREEN INDIAN RED BURNT UMBER

Supplies

- Round brush (size 3)
- 3 colors of paint
- Black permanent ink pen (size 1)

1. Using a thin permanent ink pen (size 1), outline the raspberries and add the seed details.

2. To create a background wash, apply clean water to the paper with a brush, being careful not to touch the raspberries themselves.

3. With Hooker's Dark Green, drop the pigment onto the wet paper and allow it to flow around the berries.

4. When the background is totally dry, apply wet-on-dry washes of Indian Red to the raspberries, and fill the stems with a mix of Hooker's Dark Green and Burnt Umber.

5. Add your green mix to the leaves of the berries, and create some additional ones on the vines if you like.

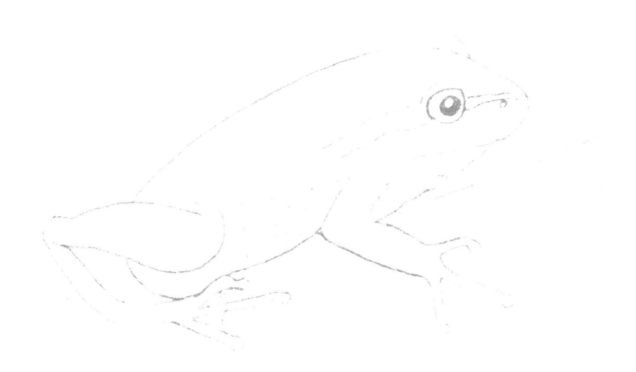

tree frog

A wet-on-wet wash allows this tree frog to look vibrant and unique. The simple washes indicate the idea of the colors instead of being super realistic. Remember, with ink and wash, your work doesn't have to be perfect! The more simplified, the better sometimes.

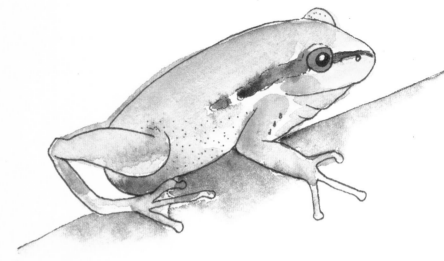

Colors

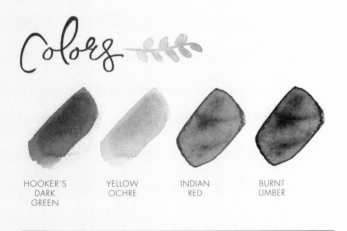

HOOKER'S DARK GREEN

YELLOW OCHRE

INDIAN RED

BURNT UMBER

Supplies

- Round brush (size 6)
- 4 colors of paint
- Black permanent ink pen (size 1)

1. Sketch the frog using a permanent ink pen, and add dot detailing to the stomach area. Sketch in the eyeball as well.

2. Fill the entire body of the frog with water, being careful to create fine strokes for the fingers.

3. Add a wash of Hooker's Dark Green to the top of the frog's body and let it fade downwards. You can tilt your paper if you need to.

4. Drop in little spots of Yellow Ochre and Indian Red to the body for a more dynamic feel.

5. Once the body has dried quite a bit, add Burnt Umber for the darker details such as under the belly, back leg, and the eye and face.

6. Add an indication of a branch using Burnt Umber.

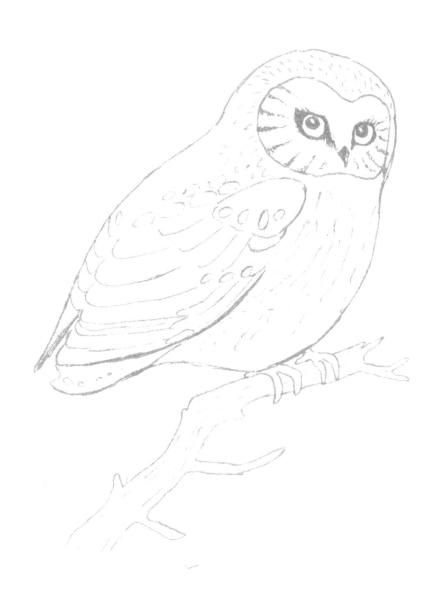

Owl

For an illustrative look, this owl is outlined quite sharply and colored in using a wet-on-wet wash of Burnt Umber and Burnt Sienna. A branch adds atmosphere and a little extra color, while a white gel pen is used to finish off the white details on the body.

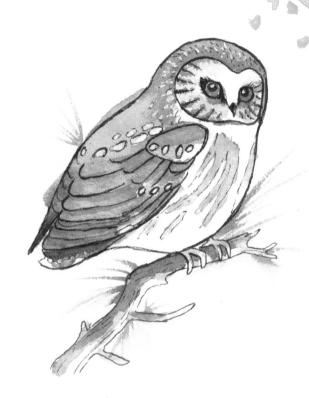

Colors

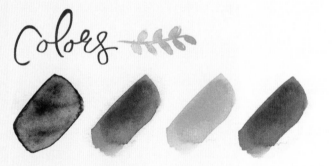

BURNT UMBER BURNT SIENNA YELLOW OCHRE HOOKER'S DARK GREEN

Supplies

- Round brush (size 6)
- 3 colors of paint
- White gel pen
- Black permanent ink pen (size 5)

1. Outline the owl using a size 5 permanent ink pen, and complete the wing and facial details.

2. Wet the body of the owl, avoiding the white areas of the chest and face. Drop in a bit of Burnt Umber, followed by a touch of Burnt Sienna. Allow the colors to blend together, and tilt your paper if you need to.

3. Add light strokes of the same color to the chest, and brush on some Burnt Umber to the branch, leaving white areas as highlights.

4. Add a wet-on-dry wash of Yellow Ochre to the eyes and a bit of your Burnt Sienna mix to the lines around the face.

5. Finish off by filling in the white spot details with a white gel pen.

6. Add Burnt Umber to the branch and long strokes of green to indicate leaves.

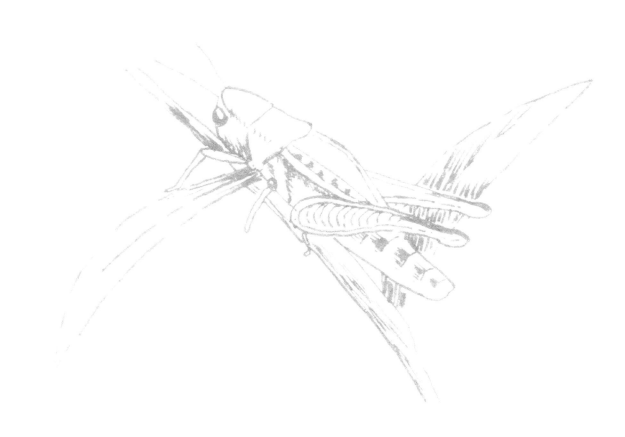

Grasshopper

Because grasshoppers like to blend in with their surroundings, you're going to mix up a couple different shades of green to complete this piece.

Use a fine tipped pen for this one. Size 1 works really well for the entire piece.

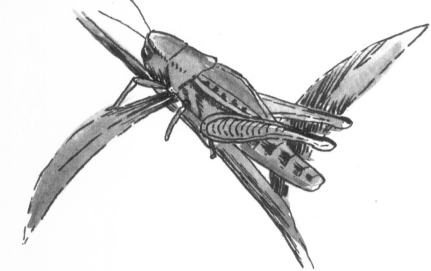

Colors

HOOKER'S DARK GREEN YELLOW OCHRE BURNT UMBER

Supplies

- Black permanent ink pen (size 1)
- Round brush (size 3)
- 3 colors of paint

1. Sketch the outlines of the grasshopper using a fine-tipped pen, then add the shadows and details using thin strokes.

2. Mix a little bit of all three colors together to create the gold-toned green on the top of the grasshopper's body. Apply your mix to the top of the head and back, as well as under the grasshopper's bottom.

3. While the previous color is still wet, apply a mix of Hooker's Dark Green with a bit of Yellow Ochre to the remainder of the body. Remember that it's okay to leave some white spots peeking through for a sketchy look.

4. Fill in the plant stem and leaves with a quick wash of Hooker's Dark Green, and add a light wash of Burnt Umber to the legs.

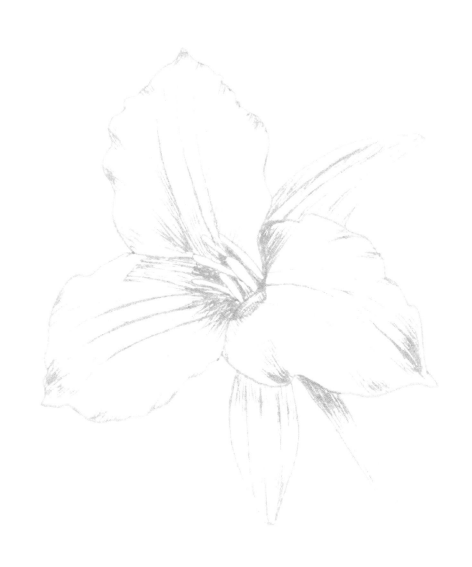

Trillium

The majority of this beautiful Trillium flower is sketched with ink, and only a minimal wash of color is added to complete the piece.

Shading is done by using a pen with a fine tip and building up your strokes as you go.

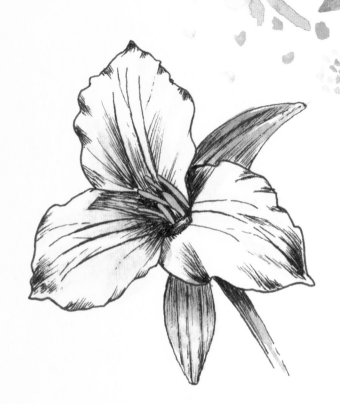

Colors

HOOKER'S DARK GREEN YELLOW OCHRE

Supplies

- Black permanent ink pen (size 1)
- Round brush (size 6)
- 2 colors of paint

1. Start by outlining the petals of the flowers with your pen. Add the center details and the main veins in the petals.

2. Using a light hand, start adding fine strokes to the darker areas of the petals to create shadows and folds. You can use a crosshatching technique as well if you like.

3. Apply the same technique to the leaves and stem.

4. Mix up some Hooker's Dark Green with Yellow Ochre. Add light washes of the color to the leaves and stem. Use a solid mix of Yellow Ochre for the center area.

5. Mix a very light shade of Yellow Ochre (almost transparent), and add a few quick strokes to each petal for dimension.

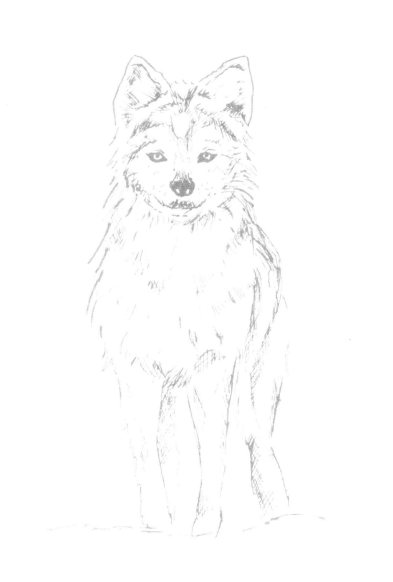

Wolf

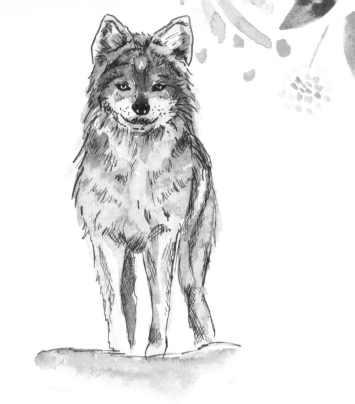

Using a mixture of greys and browns, you can create the look of multitoned fur.

The sketch lines are kept loose and broken around the outlines and smaller, shorter strokes are used to add texture and shading.

Colors

| PAYNE'S GREY | RAW UMBER | BURNT UMBER |

Supplies

- Black permanent ink pens (size 3 + 1)
- Round brush (size 6)
- 3 colors of paint

1. Using your size 3 ink pen, sketch the body of the wolf. Remember to keep the outlines wispy and broken to indicate fur.

2. With a size 1 pen, create loose, short lines on the chest, around the face, and down the legs to complete the furry look. You can use a crosshatching technique on some of the shadow areas, such as the legs, to darken your strokes.

3. Sketch in the eyes, fill in the nose, and complete the facial details with your pen.

4. With a watery mix of Payne's Grey, loosely add strokes to the body and head, keeping the majority of the color near the head.

5. While that color is still wet, do the same with Raw Umber and Burnt Umber throughout the body and allow some of the colors to blend together. Leave some white areas as well!

6. Lightly wash some Raw Umber on the ground.

titmouse

This titmouse uses wet-on-wet techniques to create some nice gradients and washes throughout its feathers. Leaving a small amount of white space in between the different-colored sections will prevent the colors from bleeding together. Shading and details are created with thin pen strokes.

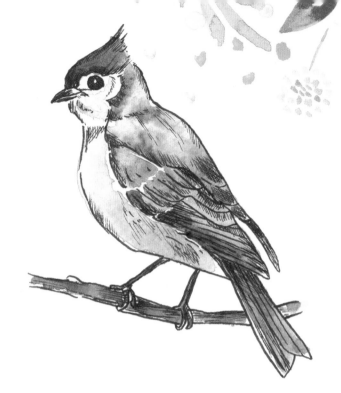

Colors

PAYNE'S GREY BURNT UMBER INDIAN RED

Supplies

- Black permanent ink pens (size 5 + 1)
- Round brush (size 6)
- 3 colors of paint

1. Draw the outline of the bird using a size 5 permanent ink pen before moving on to the interior details.

2. Start adding in the wing details and lines, switching to the size 1 pen for the shading strokes. Add strokes of shading to the belly, back, wing, head, and tip of the beak. Fill in the eyeball and sketch the legs and branch.

3. Wet the wings, tail and entire head of the bird, keeping thin, untouched areas of paper between some of the sections. Drop in some Payne's Grey, keeping it more concentrated on the head so it appears darker. While that is still wet, drop in small amounts of Burnt Umber for contrast.

4. Wet the belly and face of the bird, making sure not to touch the wet paint in the body. Drop in a bit of Indian Red to the lower portion and let it spread out. Then, add a very light mix of Payne's Grey to the face, allowing it to blend down the chest.

5. Fill in the legs and branch with Burnt Umber.

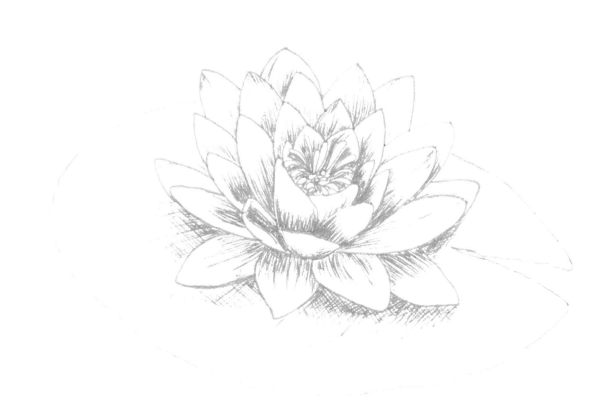

Lily Pad

This lily pad might seem complex, but it's actually not that tough! The sketch is done by creating the basic outline, and adding strokes and crosshatching for shadow details. Then, a light wash of color is applied.

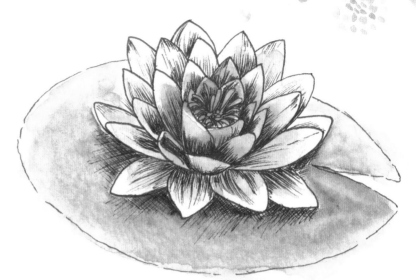

Colors

| HOOKER'S DARK GREEN | BURNT UMBER | ROSE | YELLOW OCHRE |

Supplies

- Black permanent ink pen (size 1)
- Round brush (size 6)
- 4 colors of paint

1. Start by creating the sketch with your black pen. Work on the basic outlines first, and then add the shadow detail with fine strokes. Press lightly!

2. Once the ink has dried, apply a light wash of Hooker's Dark Green to the lily pad, and drop in dots of Burnt Umber throughout for interest.

3. Once your green color has dried, gently and quickly swipe a mix of Rose onto the petals of the flower. You don't have to be perfect here; it's okay to go outside of the lines or not fill them completely.

4. Once that color has dried, darken the center a little bit more by adding another light layer of Rose.

5. When the petals are completely dry, add Yellow Ochre to the center.

For more projects and to learn watercolor painting in depth, join Dana's official online Watercolor Workshop at www.watercolor-workshop.com

Dana Fox is an artist and internet-savvy entrepreneur who creates artwork for retail products in her home studio in Ontario Canada. She developed the Wonder Forest brand in 2011 and has since found her work on the shelves of Target, Urban Outfitters, Wayfair, and Bloomingdale's, to name a few.

Her love of creativity is translated into various forms of digital and traditional art, which is demonstrated on her ever-growing YouTube Channel.

She has a fondness for animals, interior decorating, crochet, web development and, of course, watercolor painting.

Visit Dana on YouTube (www.youtube.com/thewonderforest) or Instagram (@wonderforest) to connect and share your own artwork.

INDEX